D0722722

CALGARY PUBLIC LIBRARY

DEC 2016

THINGS ORGANIZED NEATLY

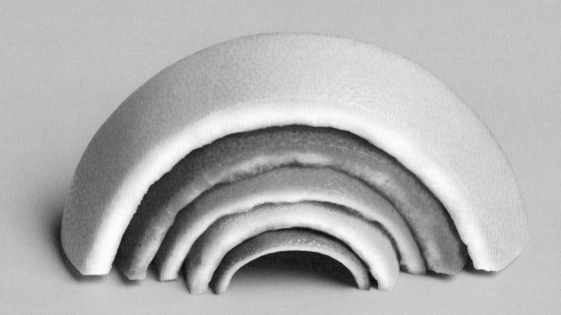

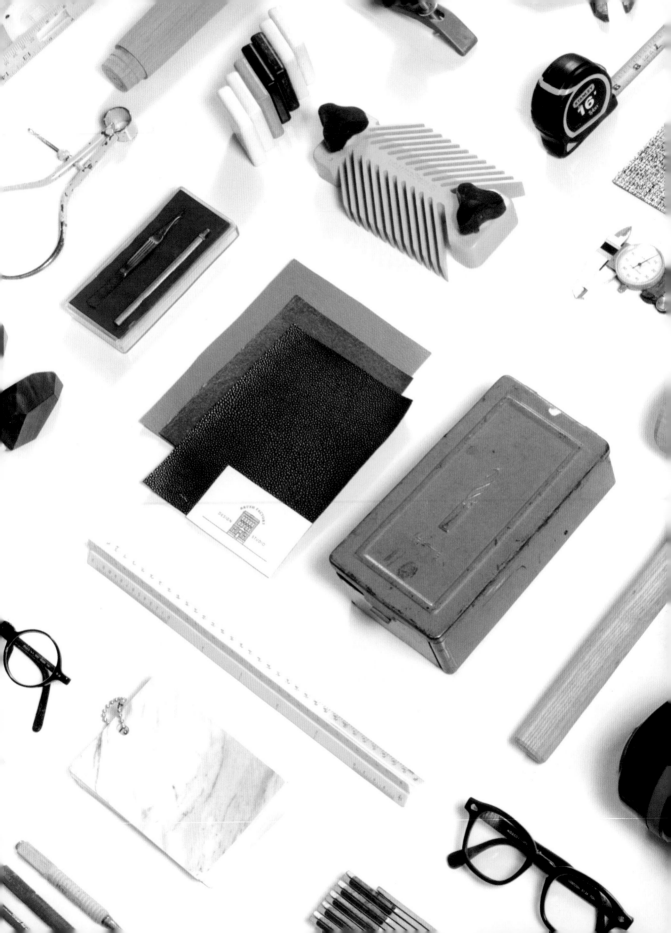

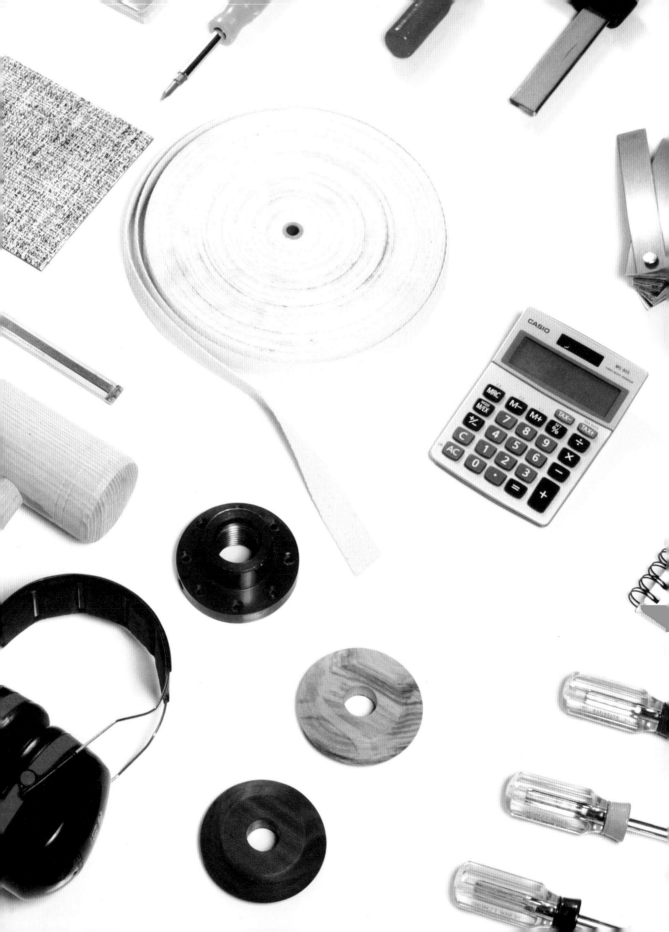

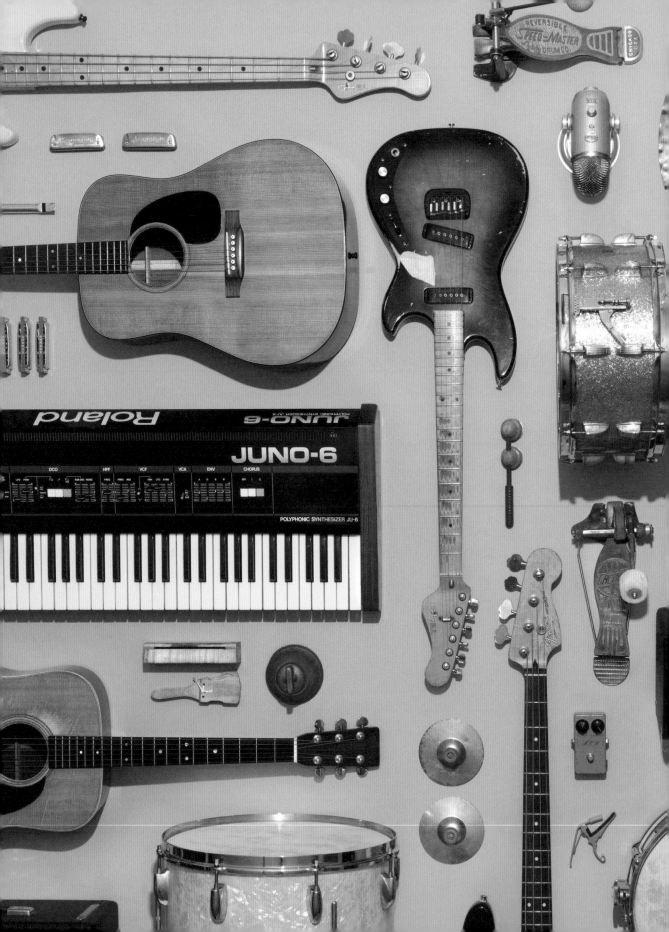

THINGS ORGANIZED NEATLY

From the blog curated by Austin Radcliffe

UNIVERSE

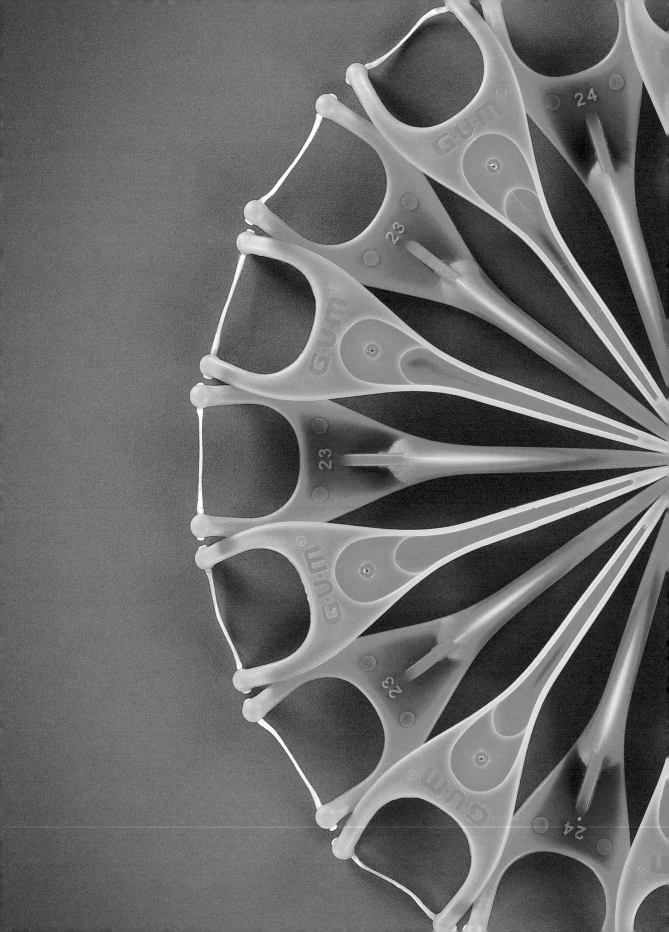

CONTENTS

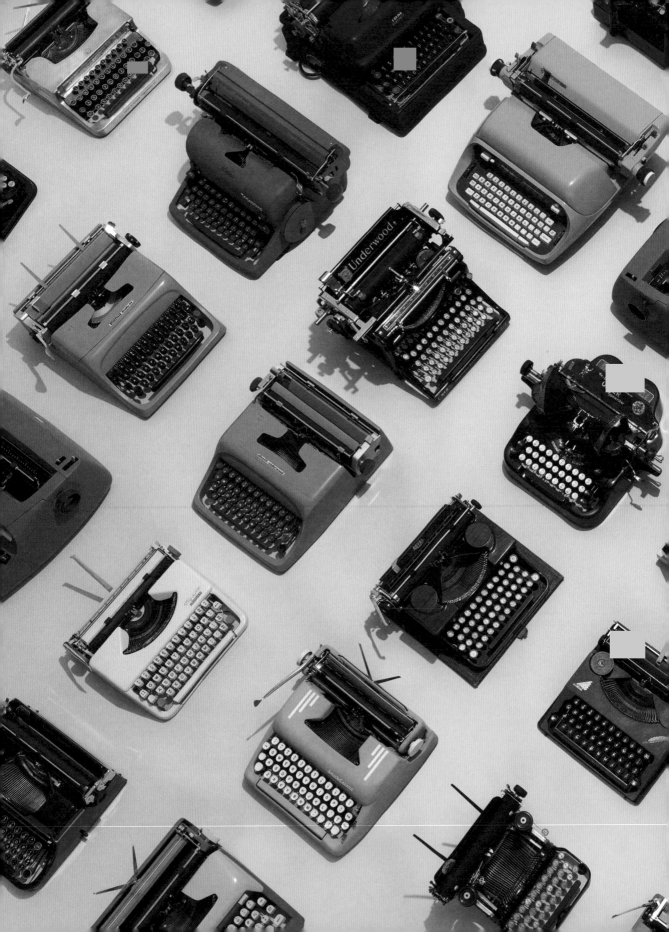

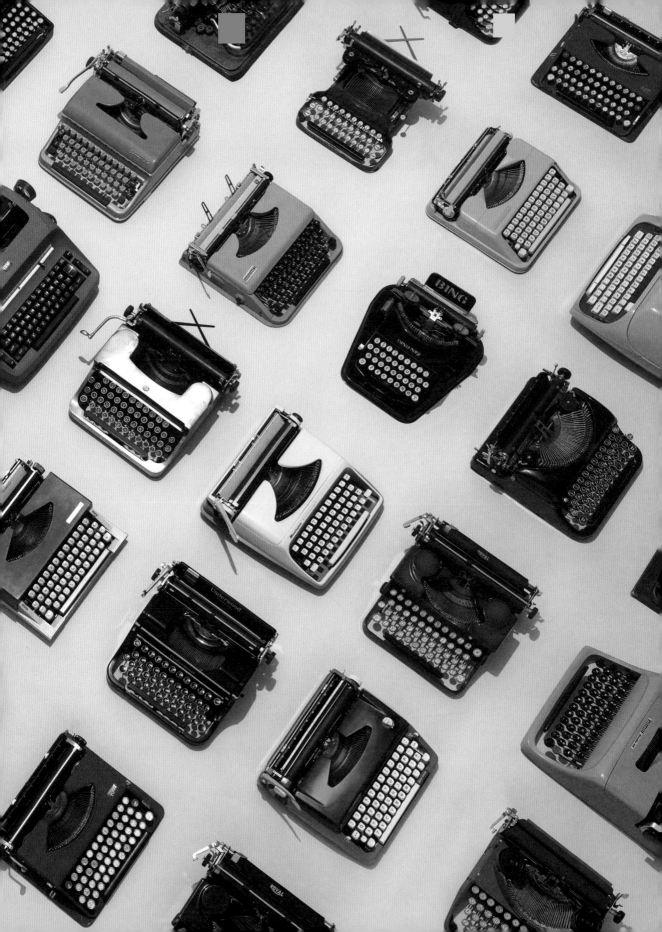

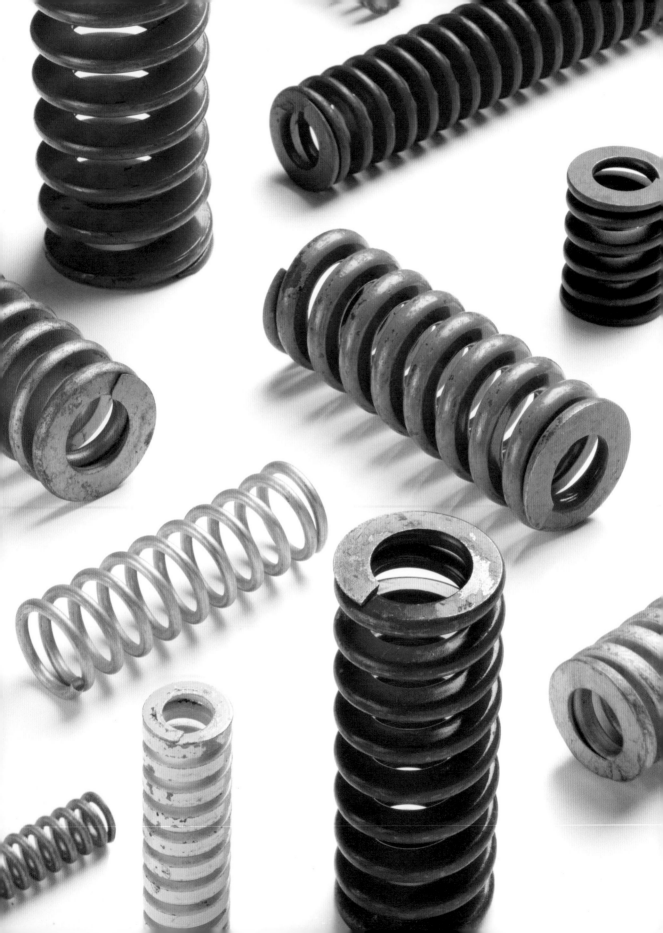

INTRODUCTION
BY AUSTIN RADCLIFFE

Organizing things neatly precedes us. Cabinets of Curiosities from the Renaissance captured imaginations with natural specimens and mysterious found objects as portals into other worlds. Scientists arrange specimens next to one another for taxonomy or comparison. Craftsmen keep their tools organized for efficiency, to keep inventory visible and available at a moment's notice. Graphic designers live by the grid to efficiently organize content. The careful arrangement of objects demonstrates a reverence for their collection.

Order in a workshop or a scientific environment arises from necessity, and organization breeds efficiency. Tom Sachs maintains "Always be Knolling" as a tenet of his studio practice. This discipline of organization reflects his respect for tools and the artistic process. Good craftsmanship requires order and exacting precision.

The aesthetic of precision is recognizable in an instant. Organization and acute attention to detail speak to the time and care given. The juxtaposition of objects imbues a collection with meaning. We can infer relationships between objects, and stories unfold as our eyes explore and

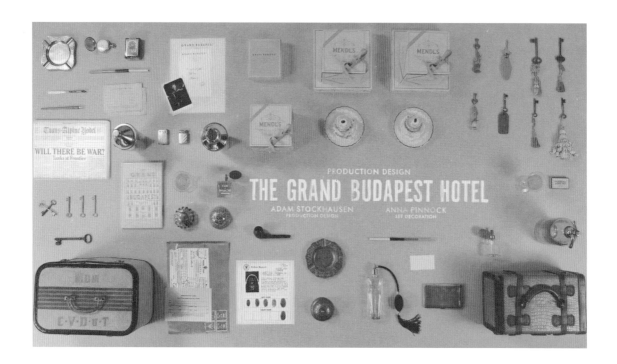

scan each page. While the selection of each item brings its own story, their careful arrangement redefines the parts with the whole.

Fans of *Things Organized Neatly* have often remarked on the sense of calm that these images inspire. In the chaotic and boundless depths of the Internet, people are drawn to the order of the grid, to parallel lines and right angles. Artists, photographers, and tastemakers are no exception, and the use of this imagery in marketing and advertising has further established the aesthetic as a phenomenon. Whether or not this cultural moment can be explained, it cannot be ignored.

The images in this book have been collected from around the world. They represent a variety of sources and artistic intentions. It is a penchant for precision that binds them. On each of these pages is an exploration of that impulse—the order that resonates from artist to viewer. It is efficient, scientific, utilitarian, beautiful, relaxing, and satisfying. This is a collection of collections. We are creating our own Cabinets of Curiosities.

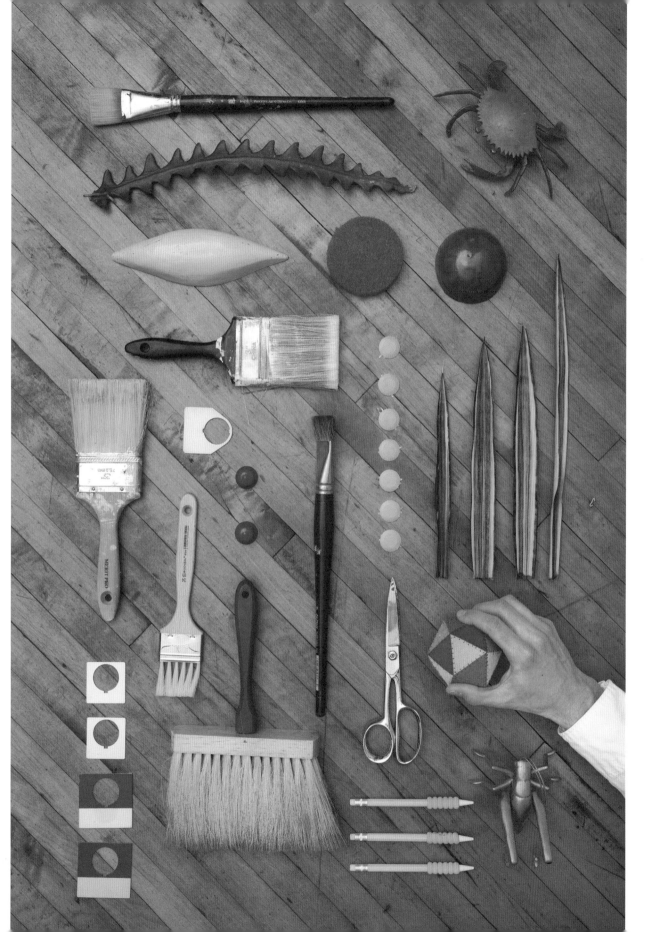

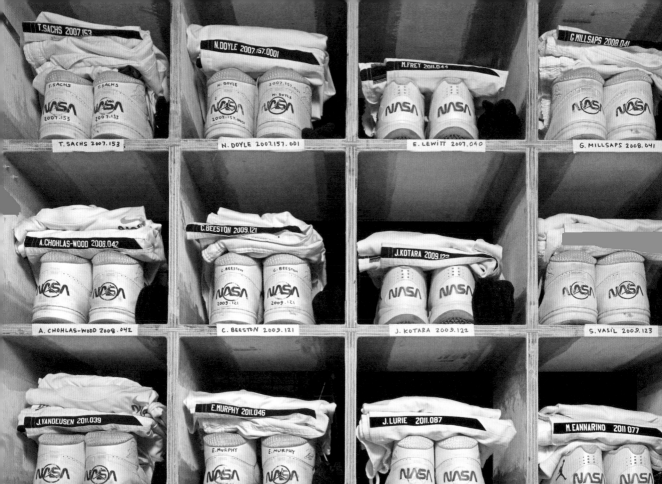

T. SACHS 2007.153

N. DOYLE 2007.157.001

E. LEWITT 2007.040

G. MILLSAPS 2008.041

A. CHOHLAS-WOOD 2008.042

C. BEESTON 2009.121

J. KOTARA 2009.122

S. VASIL 2009.123

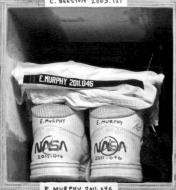

J. VANDEUSEN 2011.039

E. MURPHY 2011.046

J. LURIE 2011.087

M. EANNARINO 2011.077

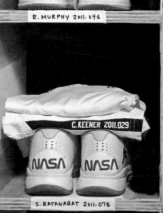

B. GULLARD 2012.022

S. RATANARAT 2011.078

V. NEISTAT 2007.170

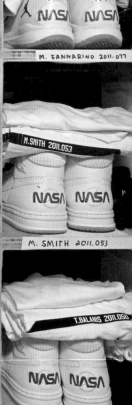

M. SMITH 2011.053

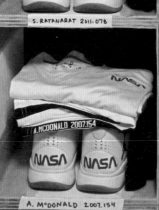

S. BODECKER 2011.054

A. McDONALD 2007.154

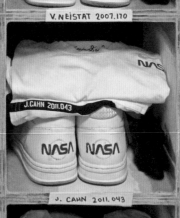

J. CAHN 2011.043

T. BALANIS 2011.050

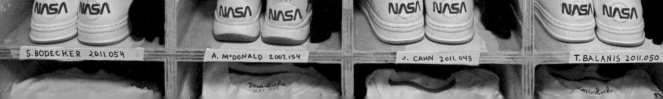

FOREWORD
BY TOM SACHS

Knoll | nōl | verb (1989 USA)
to arrange like objects in parallel or 90 degree angles
as a method of organization.

"Knolling" is the method of organizing things neatly that my studio employs. There are other names that others use: *stackenblocken*, tessellation, tidying up, making like piles, and *Things Organized Neatly*. Much is made to compare these methods with obsessive-compulsive disorder but we all know that OCD is a form of narcissism. That the patient believes if he doesn't go through a specific ritual then something terrible will happen. This is an irrational thought because it's based on fear and a sense of grand self-importance, where the subject feels that his ritual actions control unrelated events.

Knolling helps us see what's in front of us so we can discern. It helps us make more things fit into less space, or fewer things into more space, but always with the aim of understanding materials. This book shows us how things, when organized neatly, help us to build, to organize, to pack for a trip, or to conquer a nation.

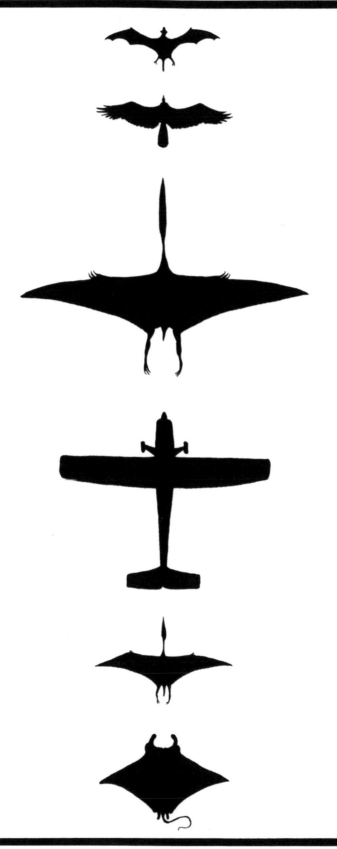

M. Dion The Aerial Realm 2014

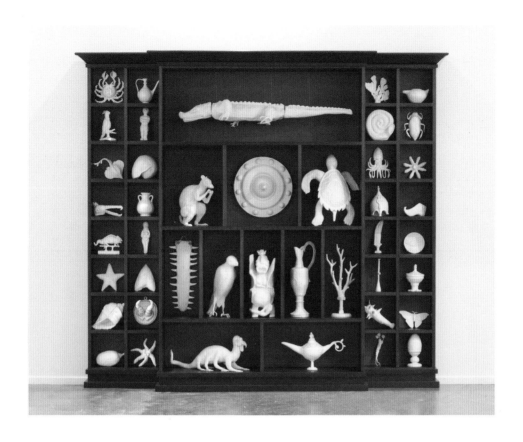

MARK DION

American artist Mark Dion was an early influence on my artistic and scientific sensibilities. His projects examine the collection rituals and common practices of hunters, explorers, scientists, and museum curators. Dion creates installations that reflect the unseen work spaces of museums and scientific archives. He constructs new Cabinets of Curiosities, approaching these collections as an archaeologist might study another culture or era. Thus, Dion's artistic practice is as scientific as it is aesthetic. He has worked with art museums and institutions around the world, including Guggenheim Museum Bilbao, Harvard University Art Museums, the Metropolitan Museum of Art and MoMA PS1 in New York, the Natural History Museum and Tate Gallery in London, and New York's Whitney Museum of American Art.

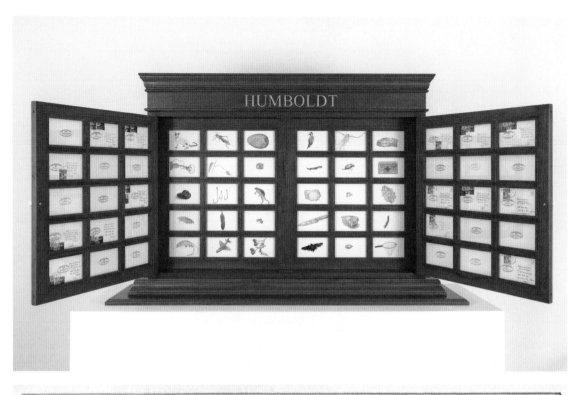

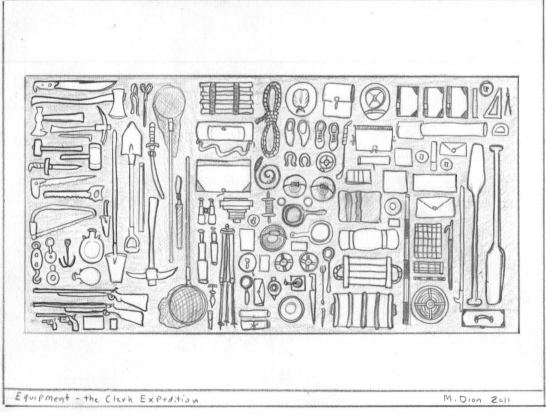

Equipment - the Clark Expedition M. Dion 2011

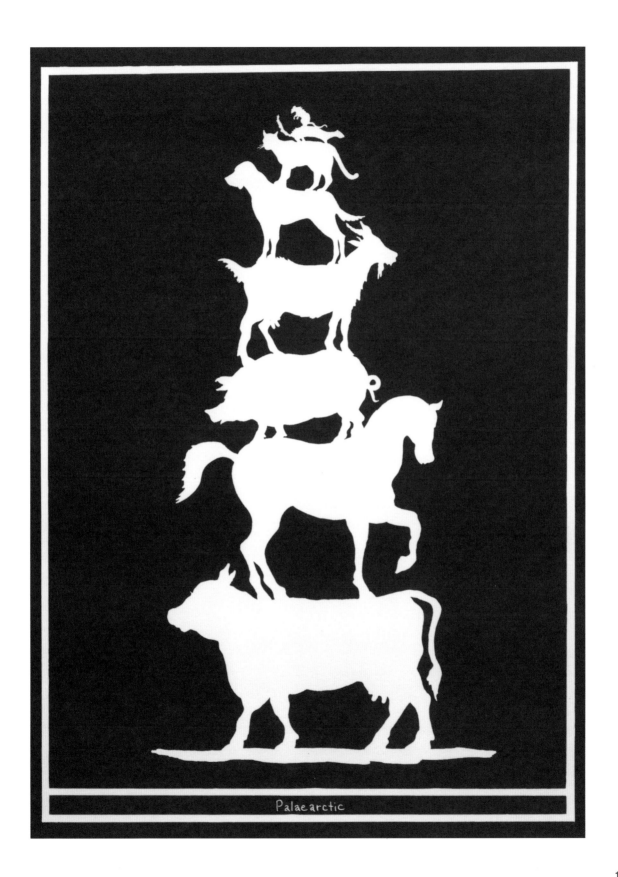

Palaearctic

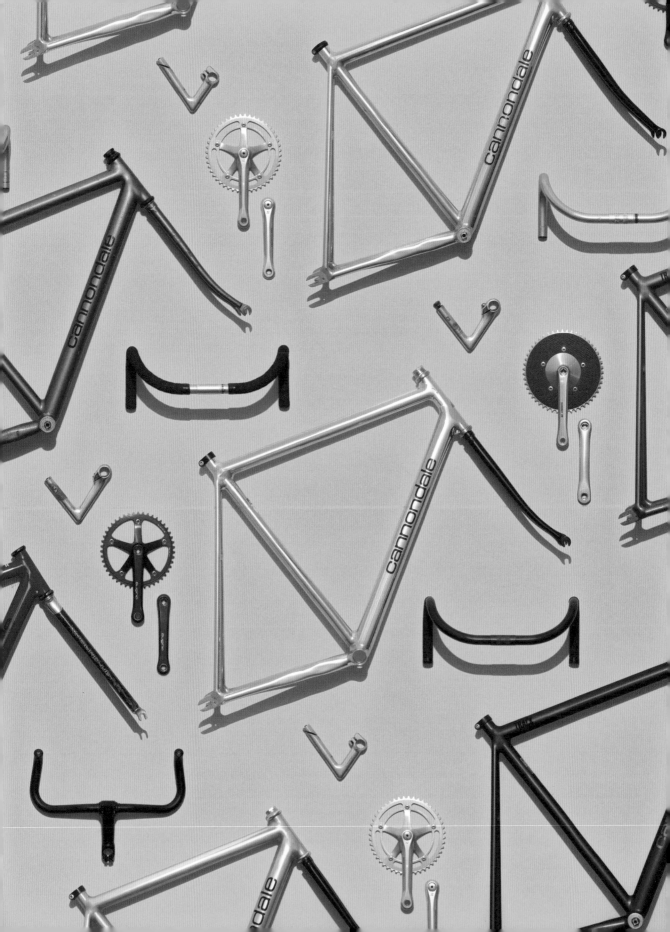

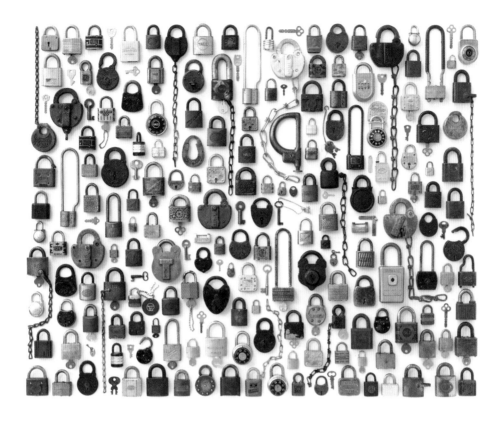

JIM GOLDEN

Portland-based Jim Golden is a veteran photographer of neatly organized collections. He creates beautiful layouts of collected objects with a sharp eye for design. His juxtapositions create storylines within his compositions, and personal narrative often influences his concepts. In addition to his *Collections* series, he also celebrates the precursors to computers in his *Relics of Technology* series. Golden's work has been featured in a wide variety of outlets including *Hypebeast*, the International Photography Awards, PDN Photo Annual, and *Wired*.

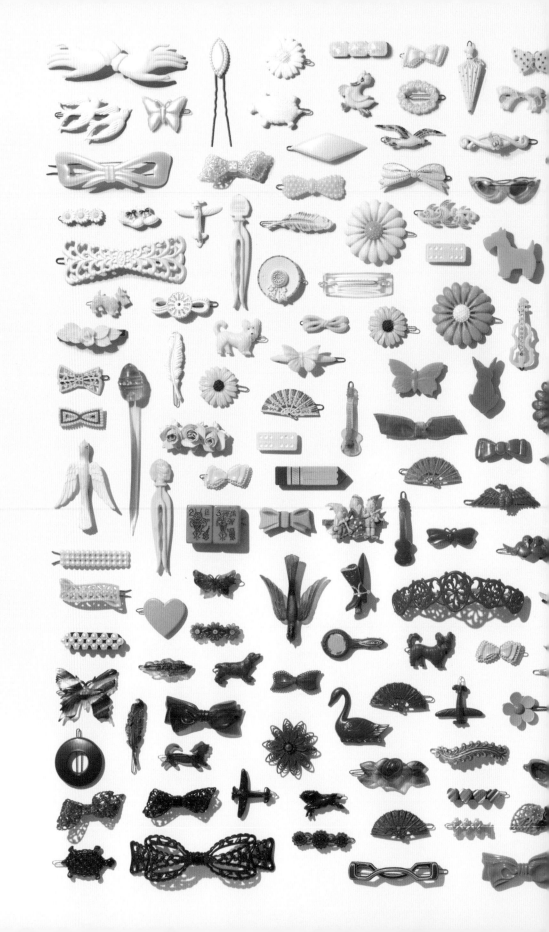

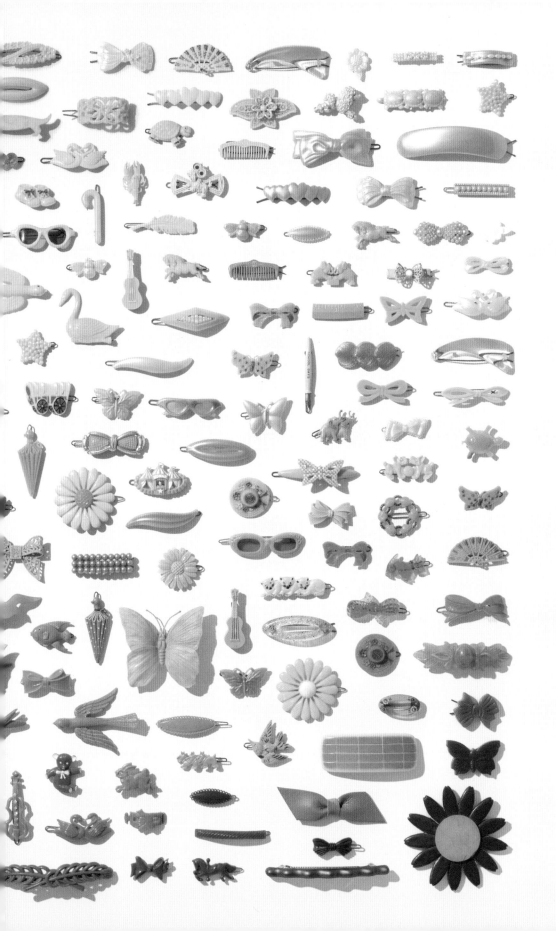

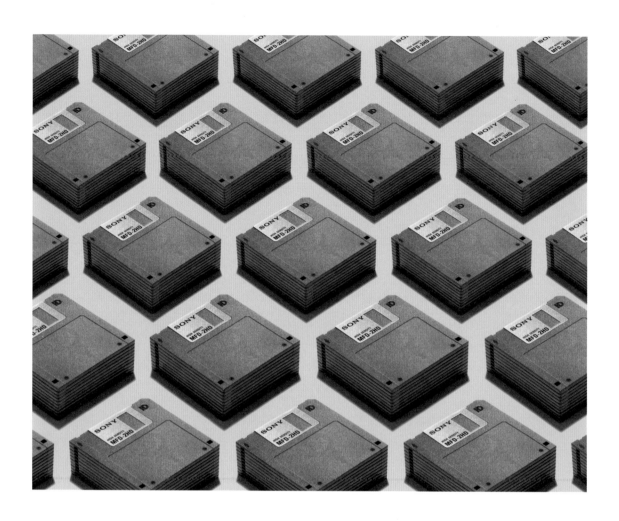

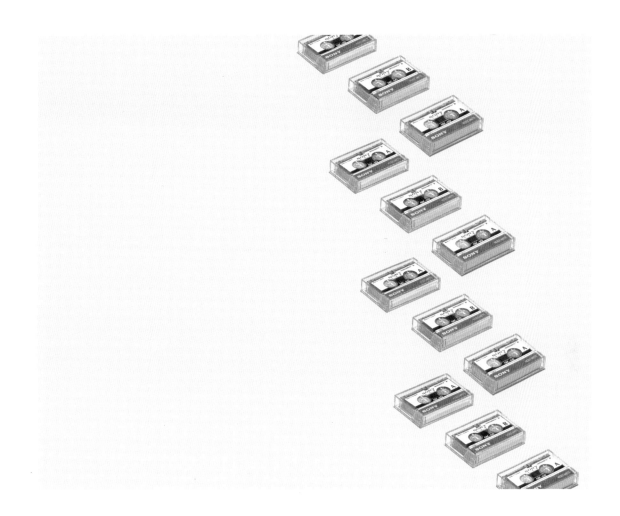

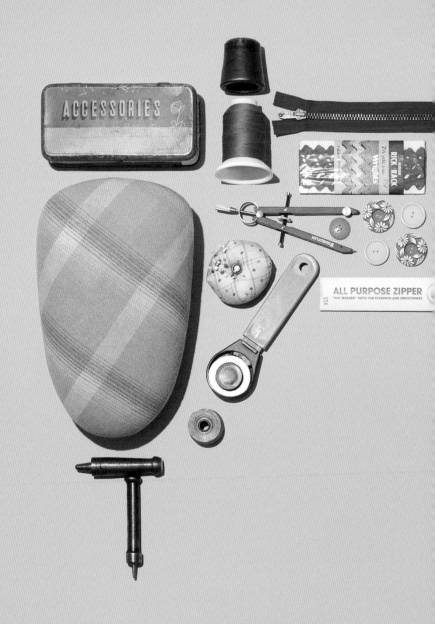
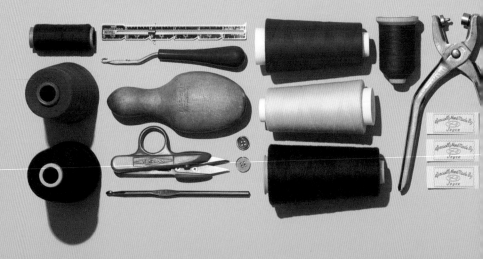

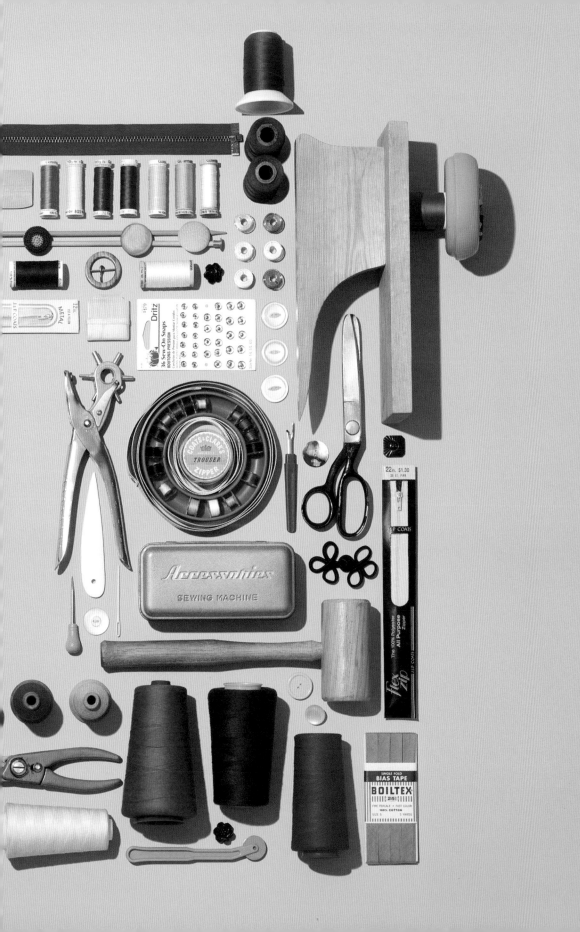

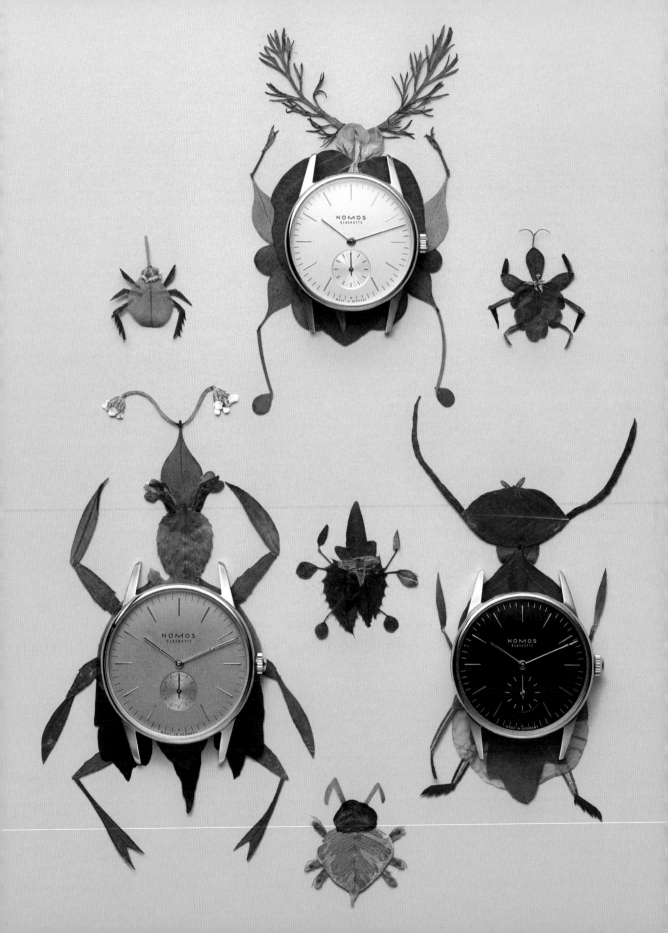

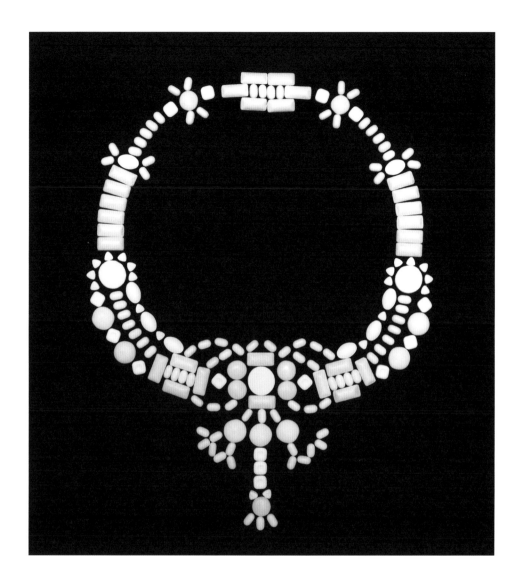

SARAH ILLENBERGER

In the twenty-first century, when so many artists and illustrators use computer illustration to create work, Berlin-based artist Sarah Illenberger is a unique visual storyteller who crafts illustrative objects and environments by hand—food made of paper, rainbows and rain clouds made of food, insects constructed with leaves, skeletons made from metal door handles. Her work blends illustration, graphic design, sculpture, and photography in a way that ignites the imagination and rewards exploration of her details. She has created work for Hermès, *Wallpaper**, the *New York Times*, and *Time*.

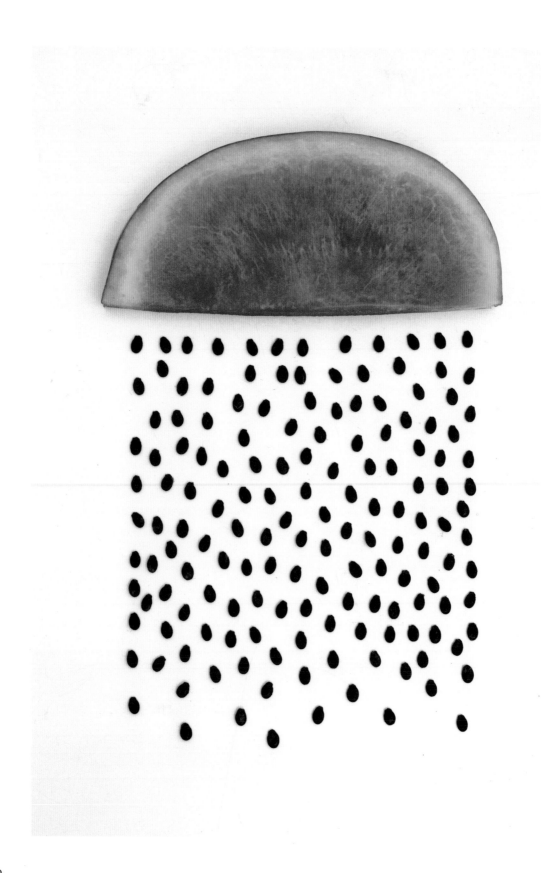

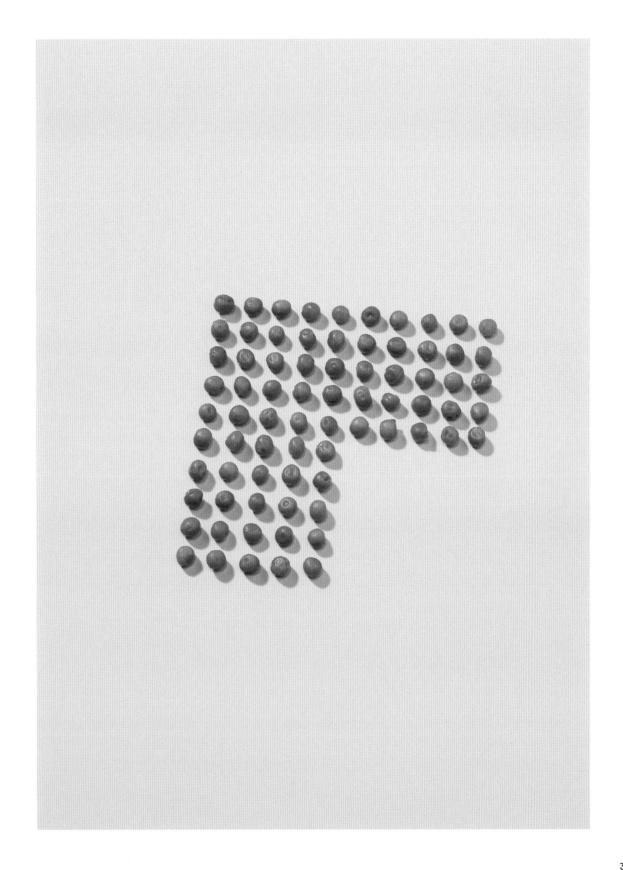

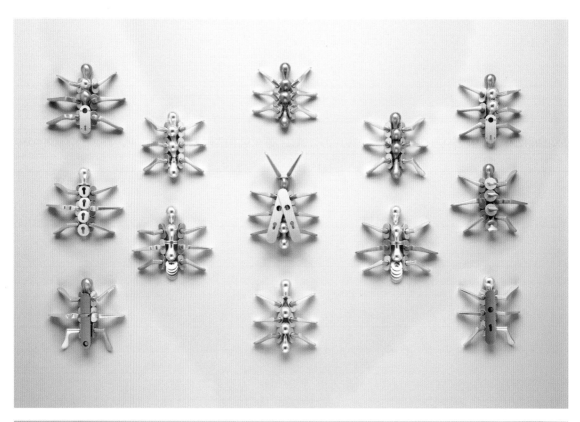

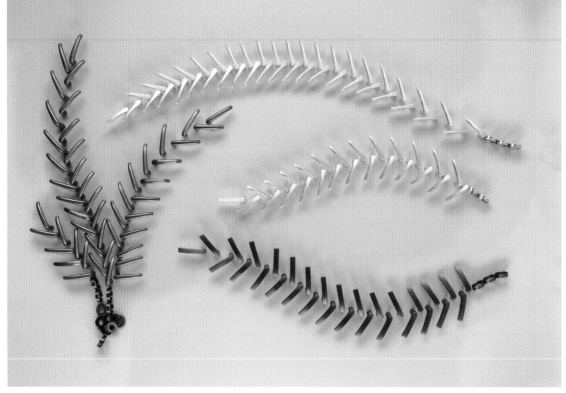

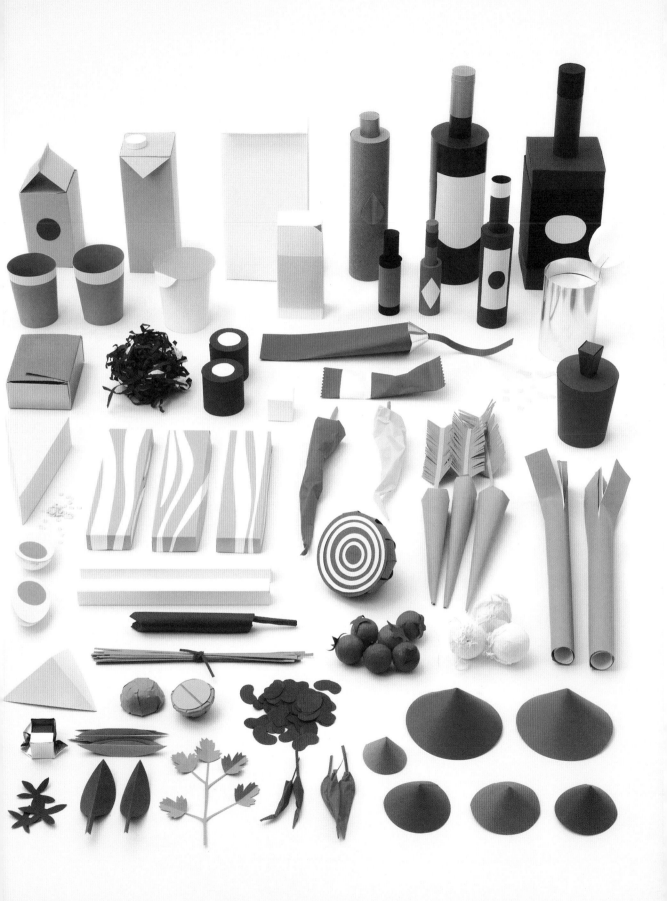

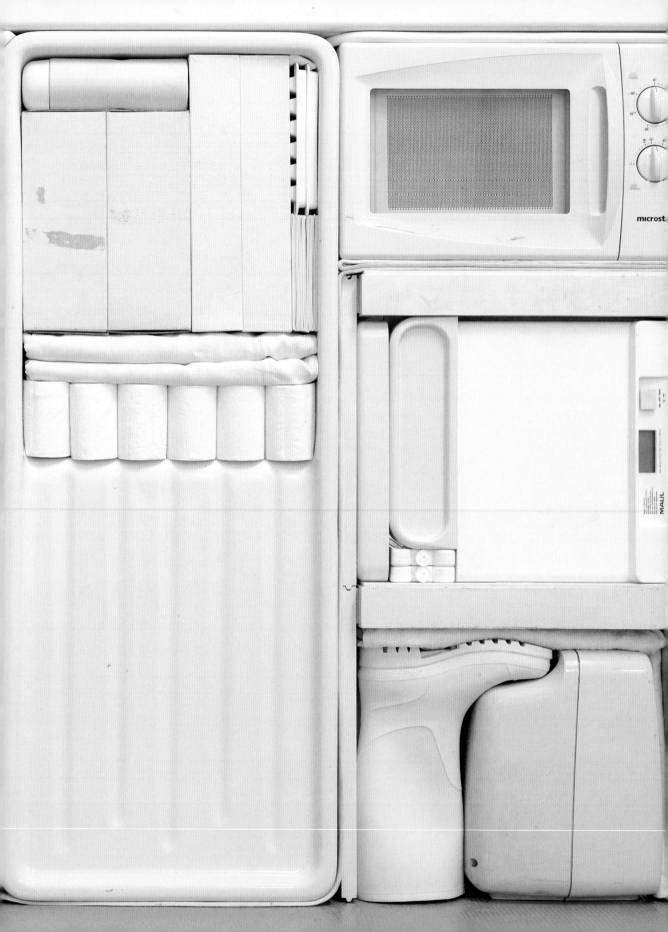

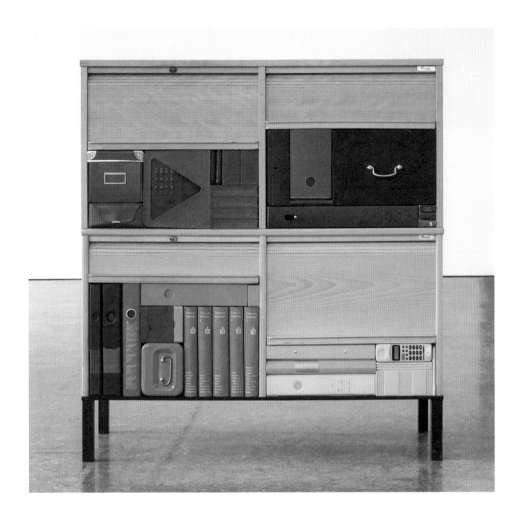

MICHAEL JOHANSSON

One of the first images I posted on *Things Organized Neatly* was a Michael Johansson sculpture. His "real-life Tetris" installations are stacked and packed everyday objects, separated by color, and fit together like a 3-D puzzle. Site-specific installations that fill a doorway, freestanding collage cubes, and even cars and shipping containers have been included in Johansson's projects. His work has been commissioned and exhibited in galleries and museums around the world.

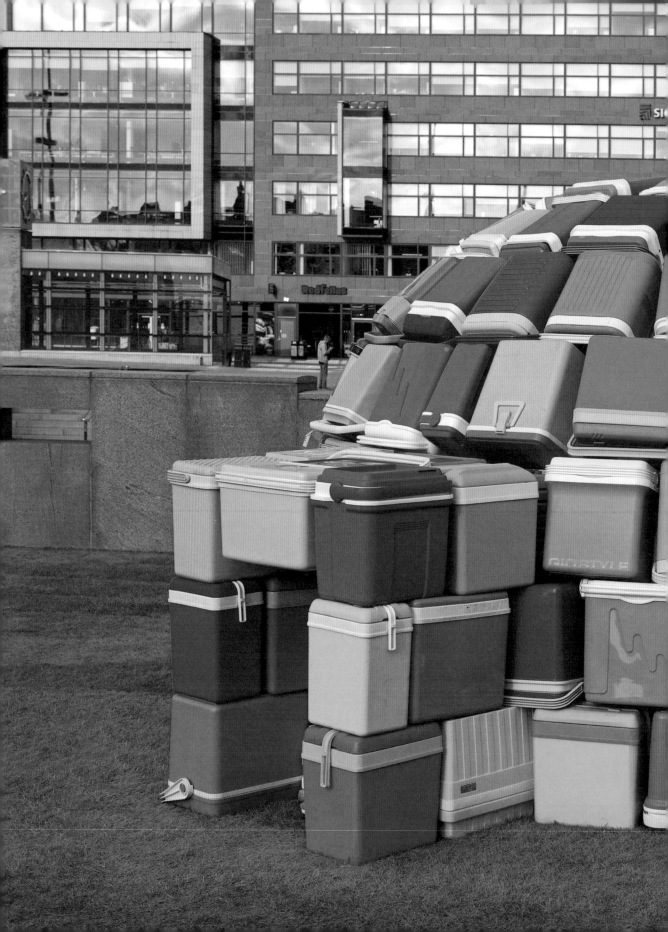

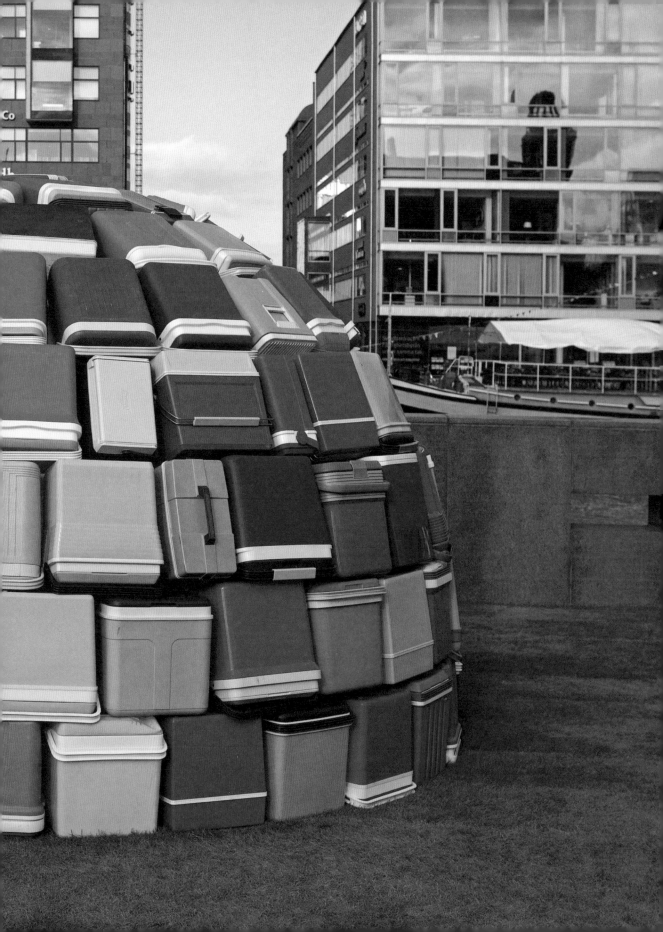

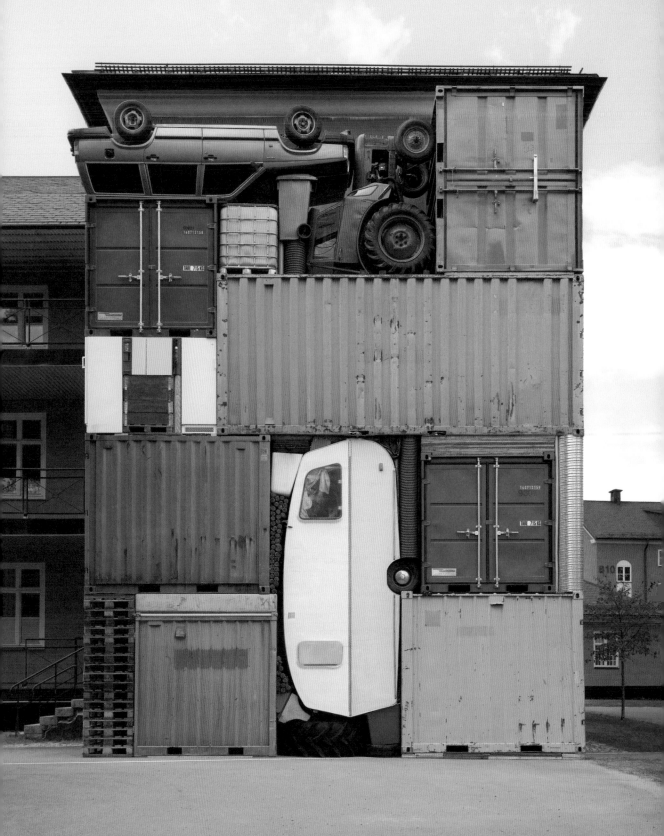

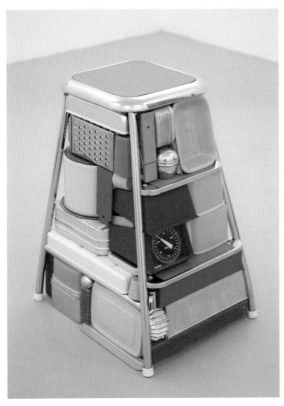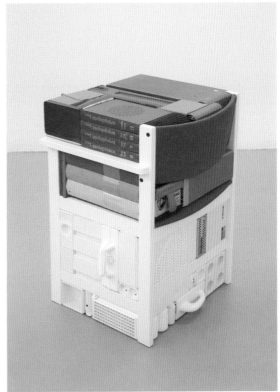

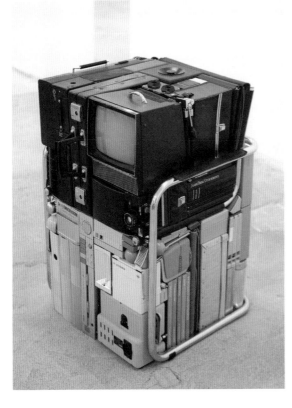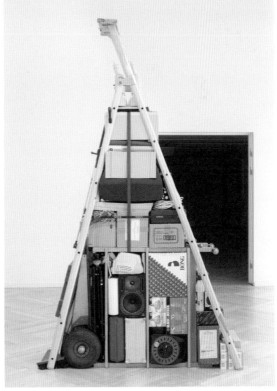

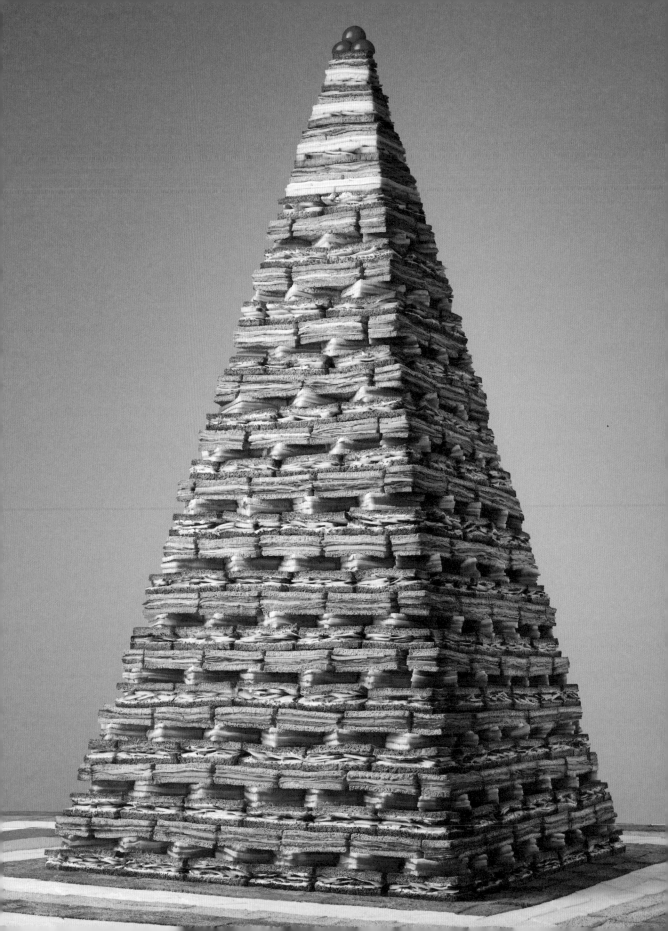

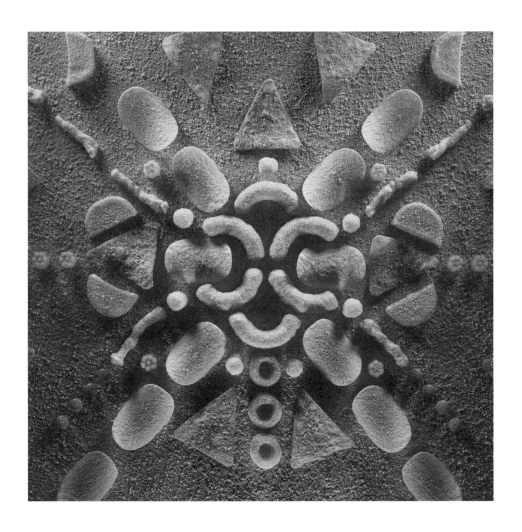

SAM KAPLAN

Sam Kaplan loves to play with his food. He creates striking commercial still-life photographs, making snacks, cups of Gatorade, and everyday consumables look like a grand sci-fi movie set. Kaplan is based in New York, and his clients include the *New York Times Magazine*, *Fortune*, Gatorade, and Nissan. His sharp technical skills and precision might leave you wondering, "Did he actually build that?" He did.

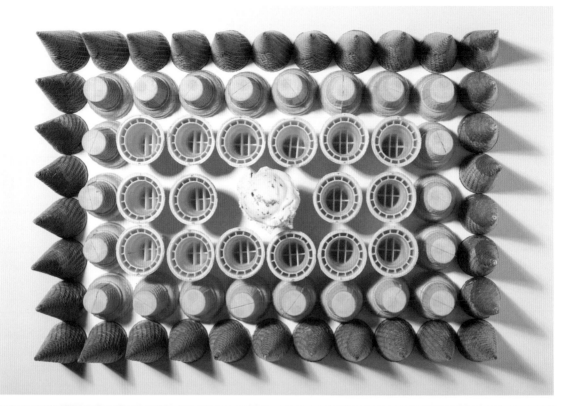

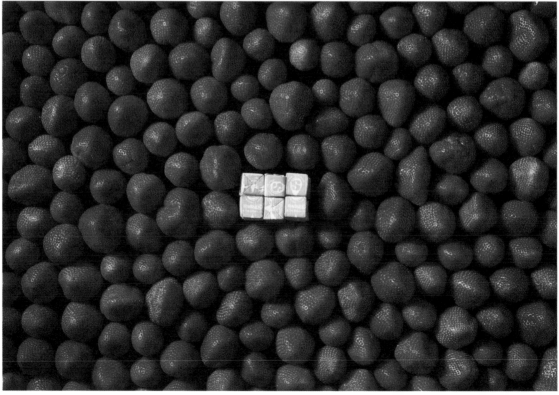

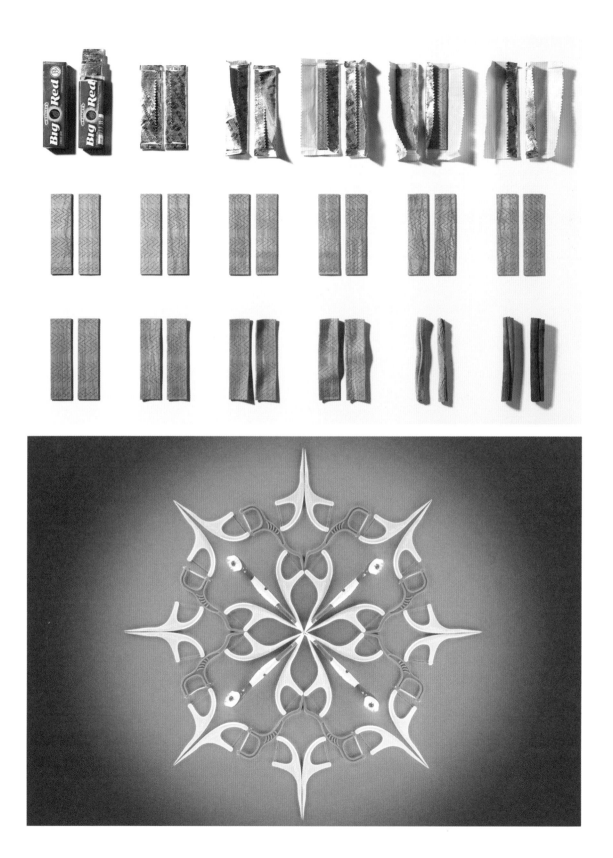

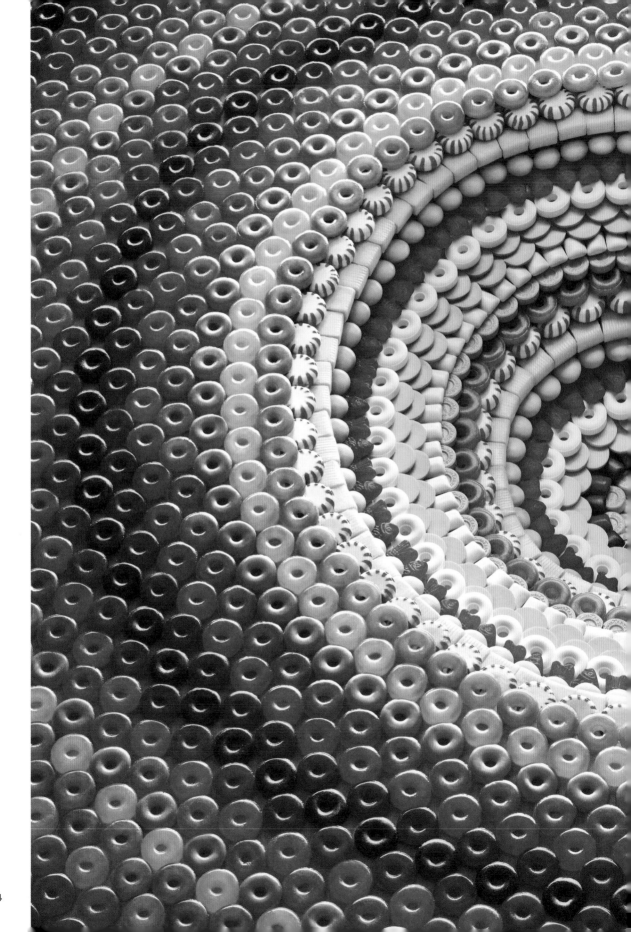

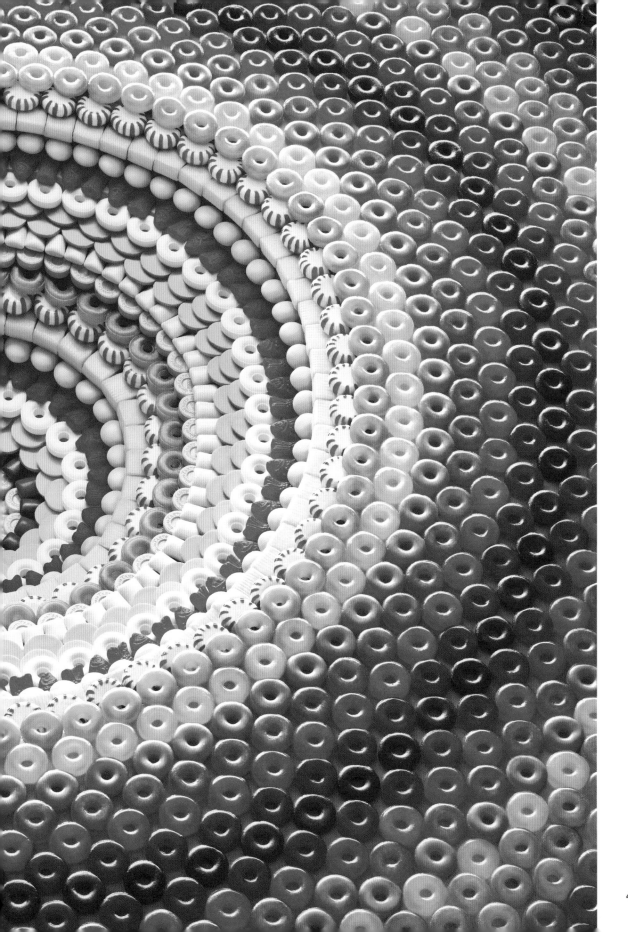

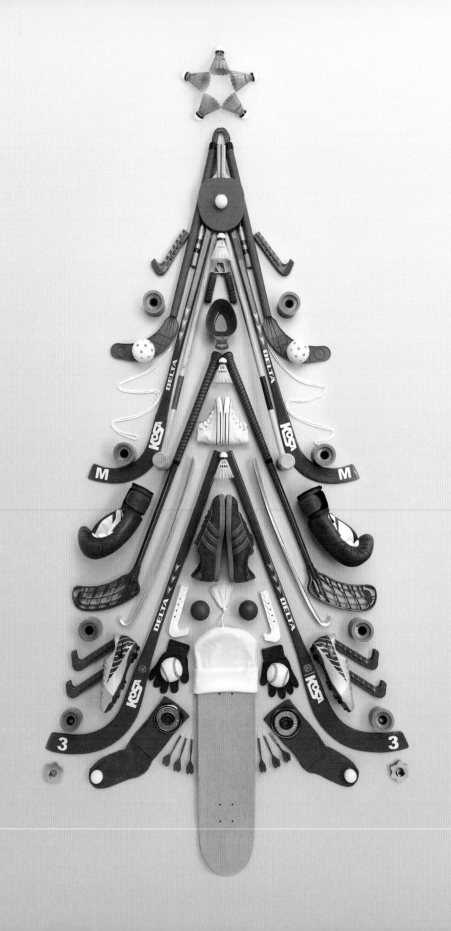

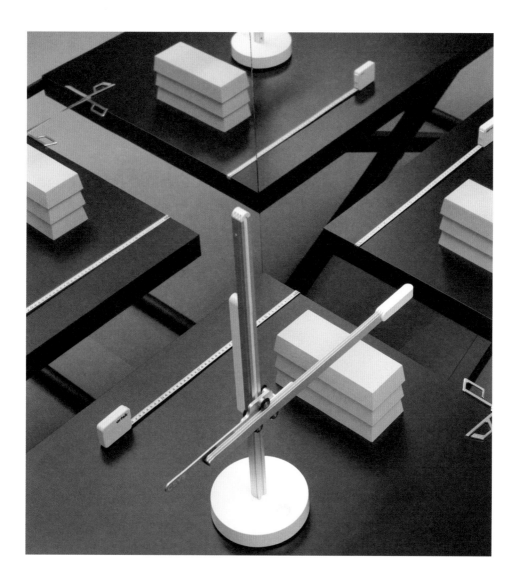

CARL KLEINER

I first connected with Carl Kleiner over his iconic IKEA cookbook project, *Homemade Is Best*. The book features photographs of meticulously arranged raw ingredients, and on the following pages, the finished baked goods (neatly organized, of course). Upon his request, IKEA shipped me a copy from Sweden. Thus, *Homemade* became my first tangible reward from a purely digital project. Kleiner has continued to create playful, technically masterful photographs for clients such as Google, Herman Miller, IKEA, Sony, *T Magazine*, and *Wallpaper**.

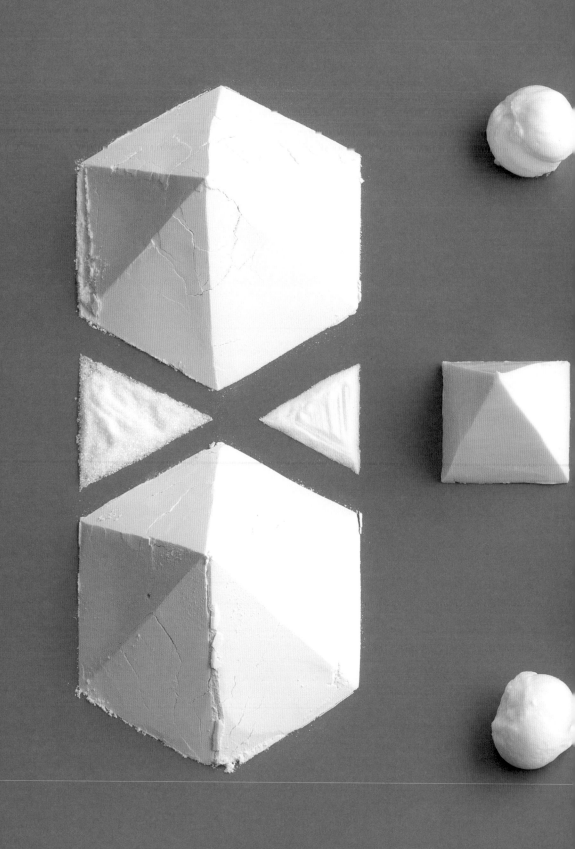

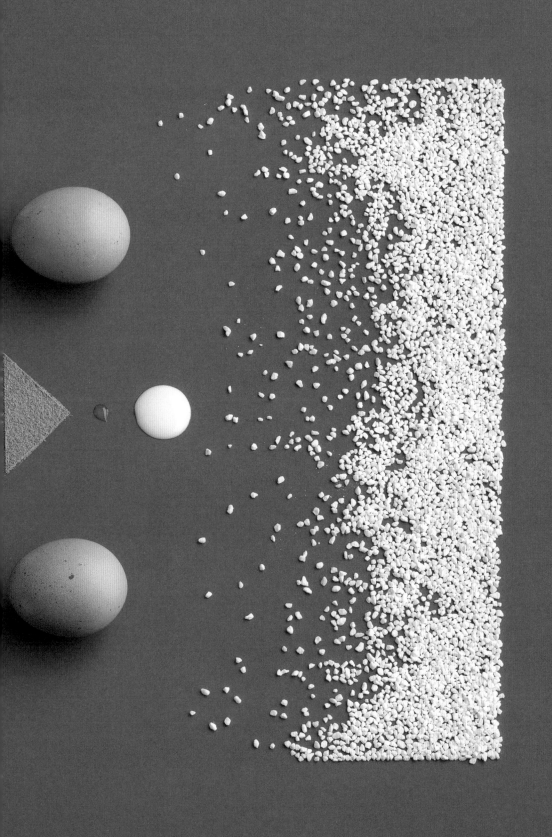

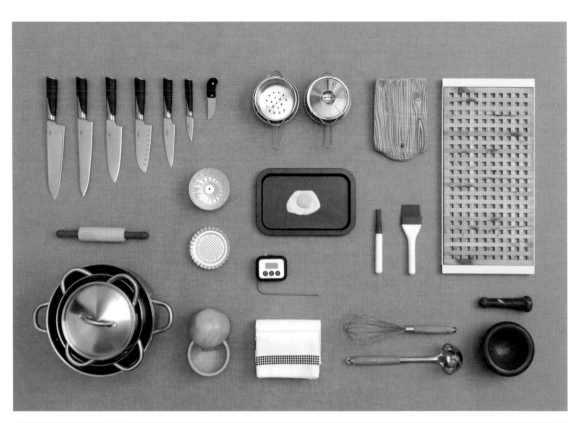

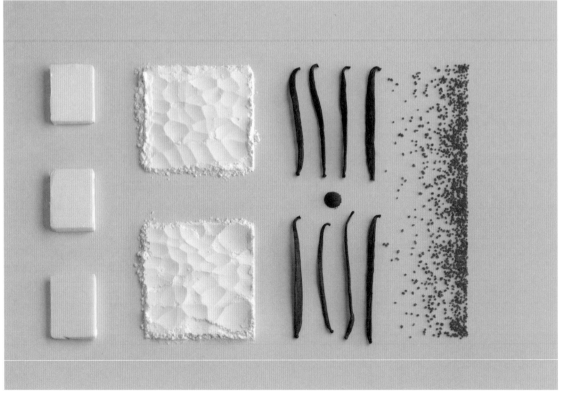

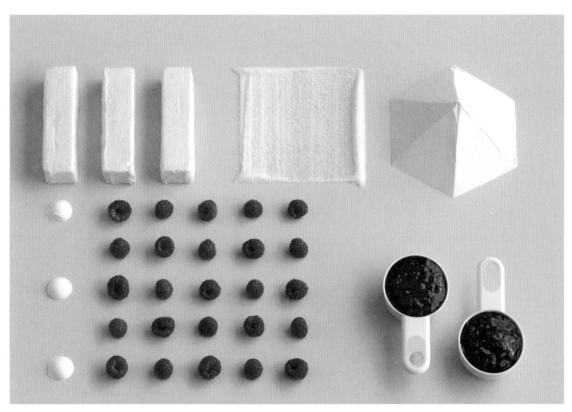

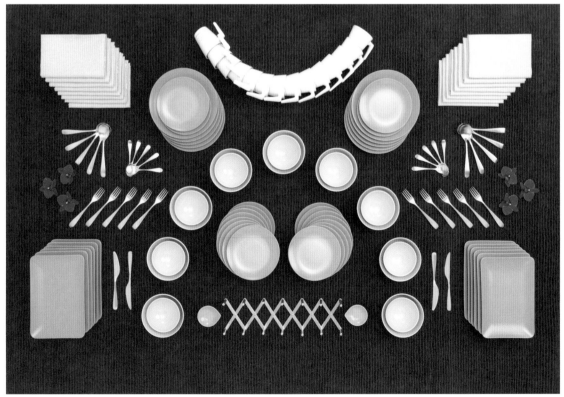

51

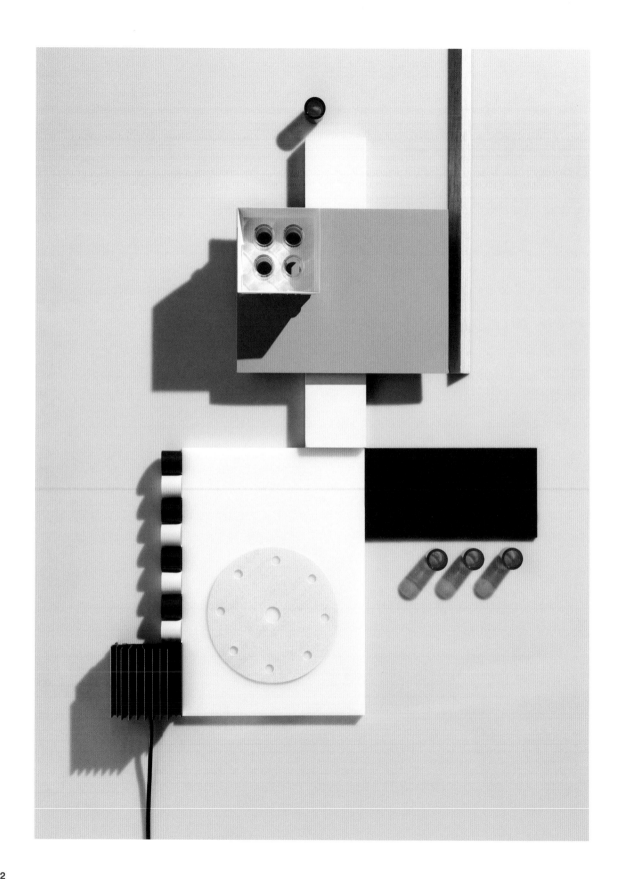

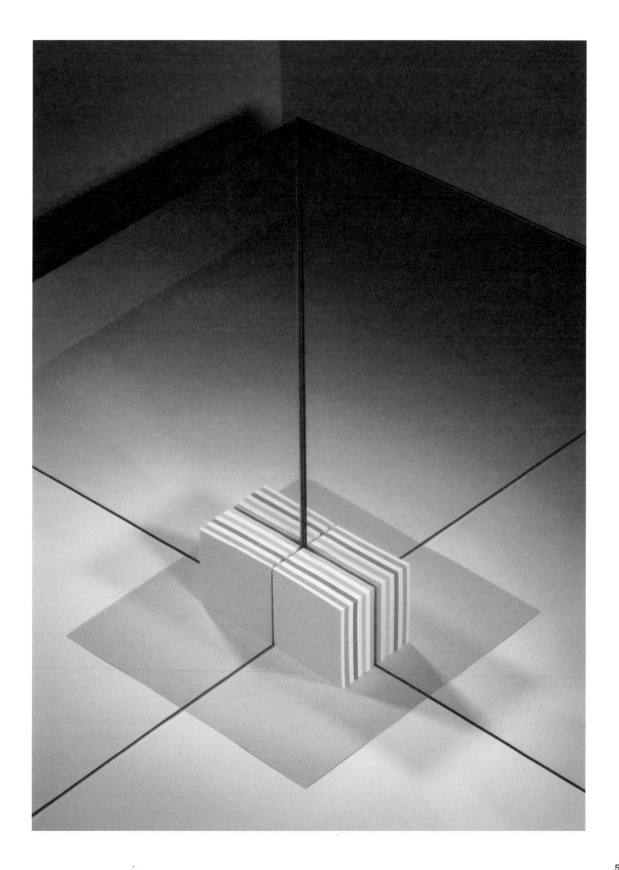

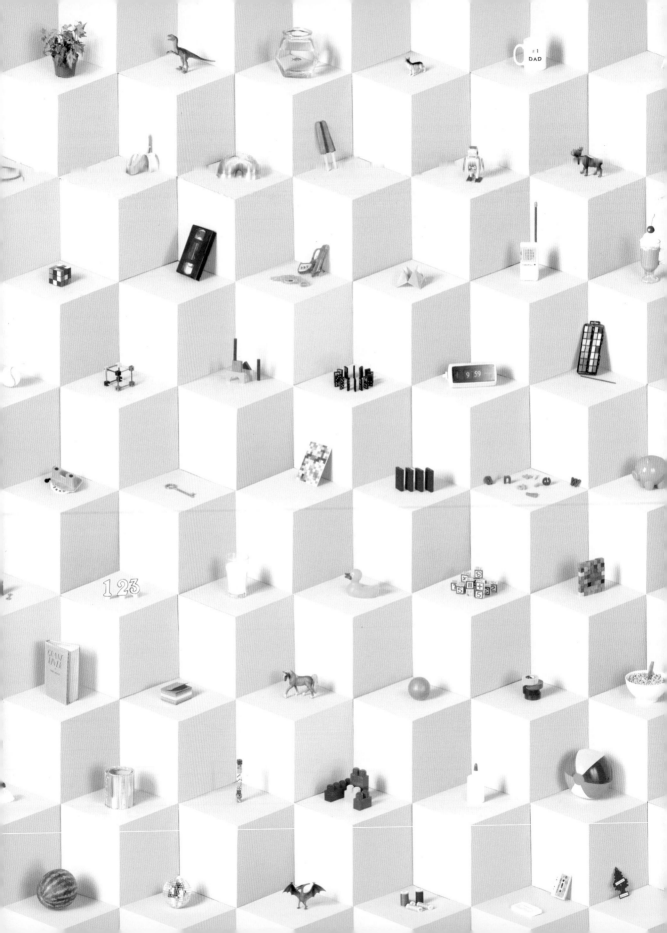

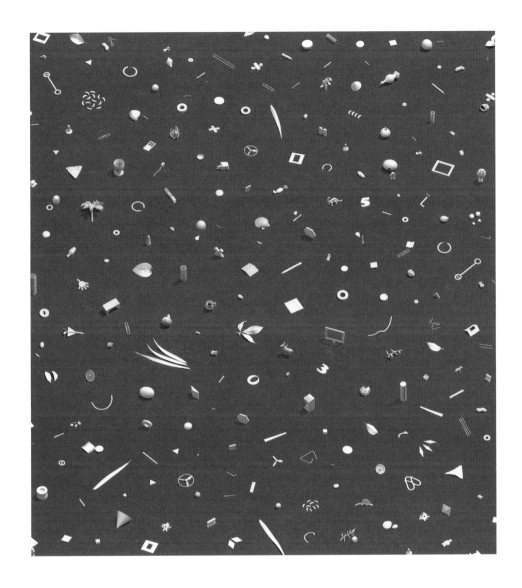

ANDREW B. MYERS

Andrew B. Myers and I share a love for diagrams, colorful flags, graphic simplicity, and humor. He uses his camera to create minimalist compositions on vast graphic landscapes. The scale can be initially disorienting, but a patient audience is rewarded with small-scale narratives and visual puns. Myers, who grew up in the countryside of Ontario, Canada, now lives and works in New York for clients including *Bloomberg Businessweek*, *Fast Company*, Google, Mr Porter, Sirius XM, and *Vice*.

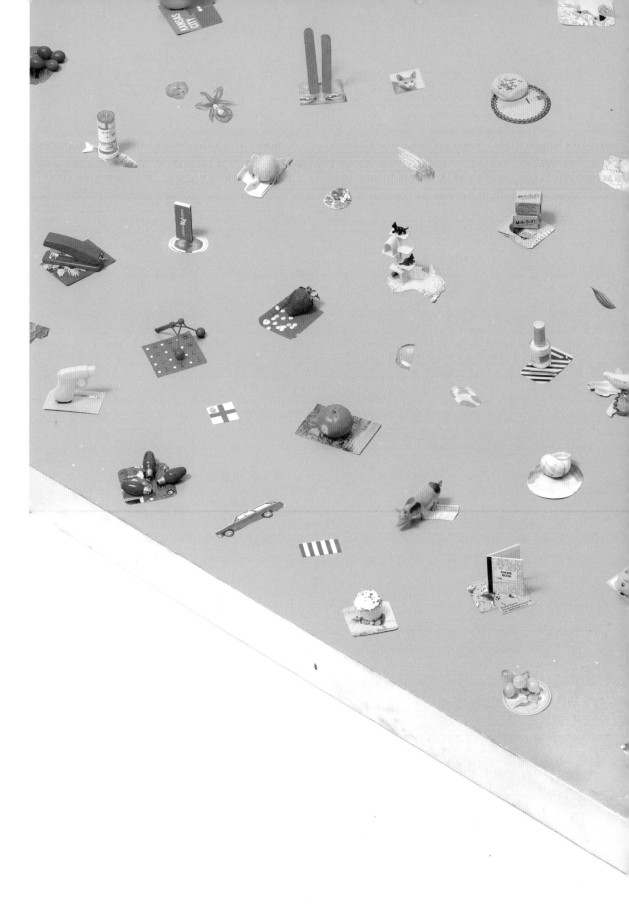

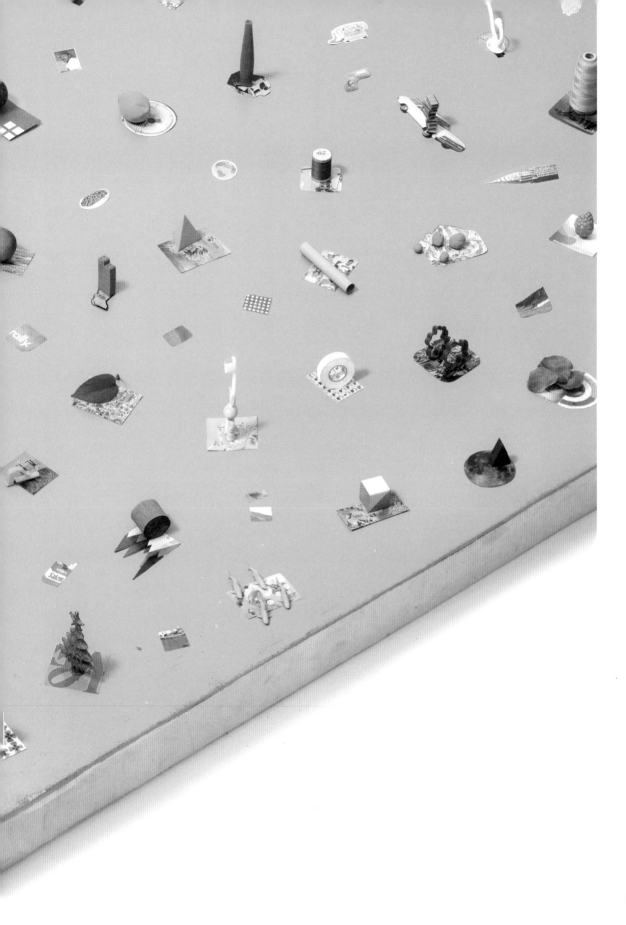

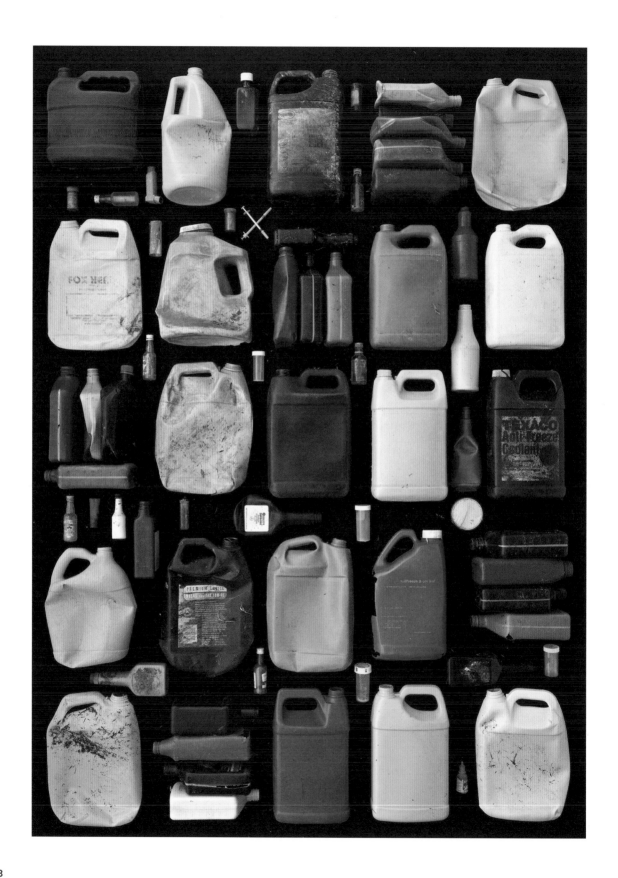

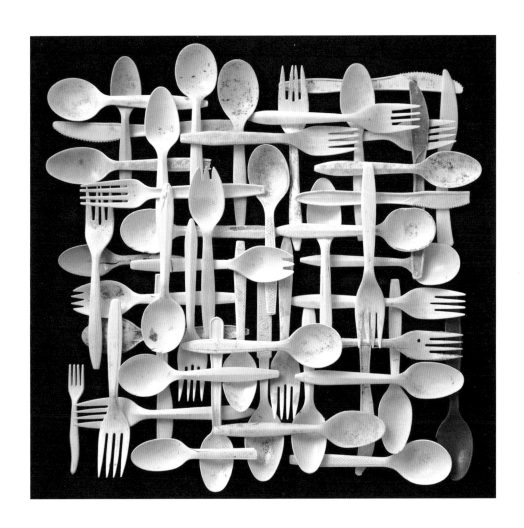

BARRY ROSENTHAL

Barry Rosenthal is a self-described urban archaeologist, photographer, sculptor, and collector. He finds man-made detritus and lost objects littering beaches and cities and brings them into his studio to catalog, arrange, and document. Rosenthal photographs large collections of shoe soles, plastic garbage, or glass bottles, grouped by color or type and arranged very carefully. His work has been seen in *Feature Shoot*, Smithsonian.com, *National Geographic Brasil*, and the Museum of Modern Art, New York.

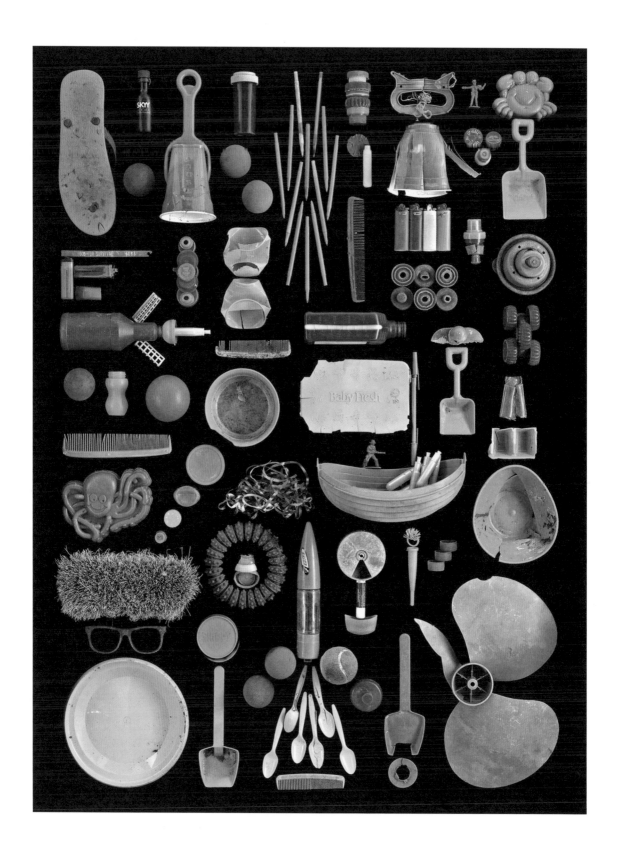

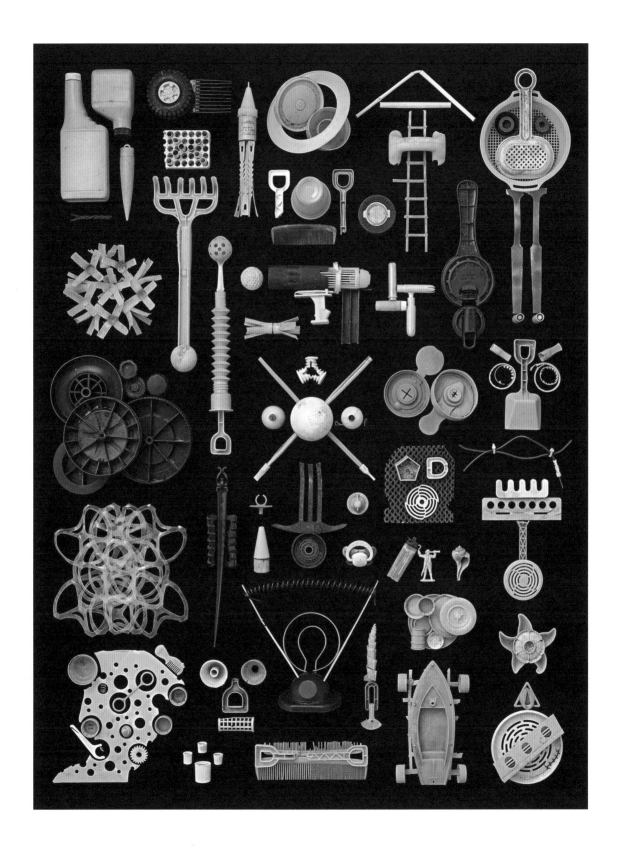

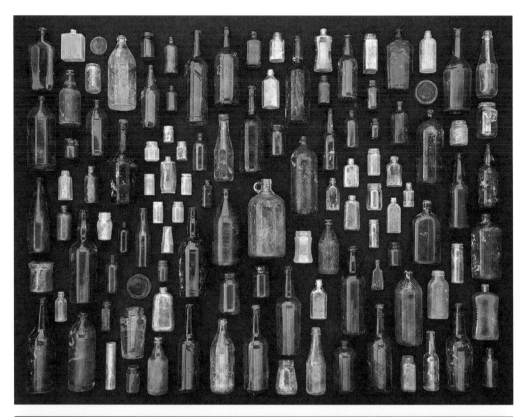

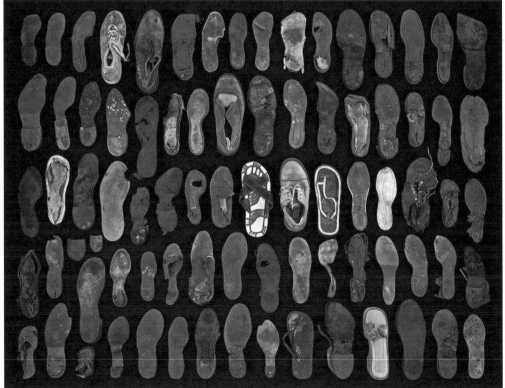

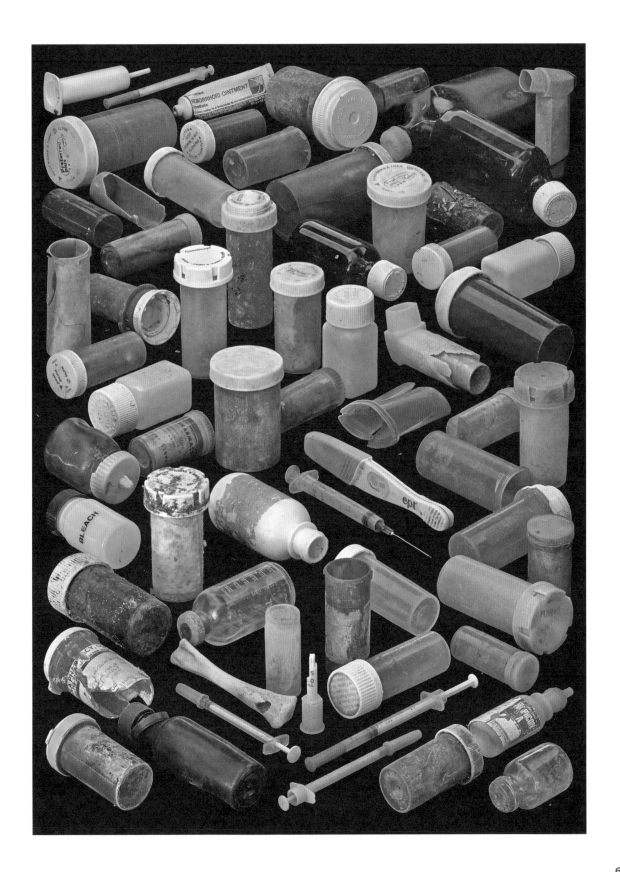

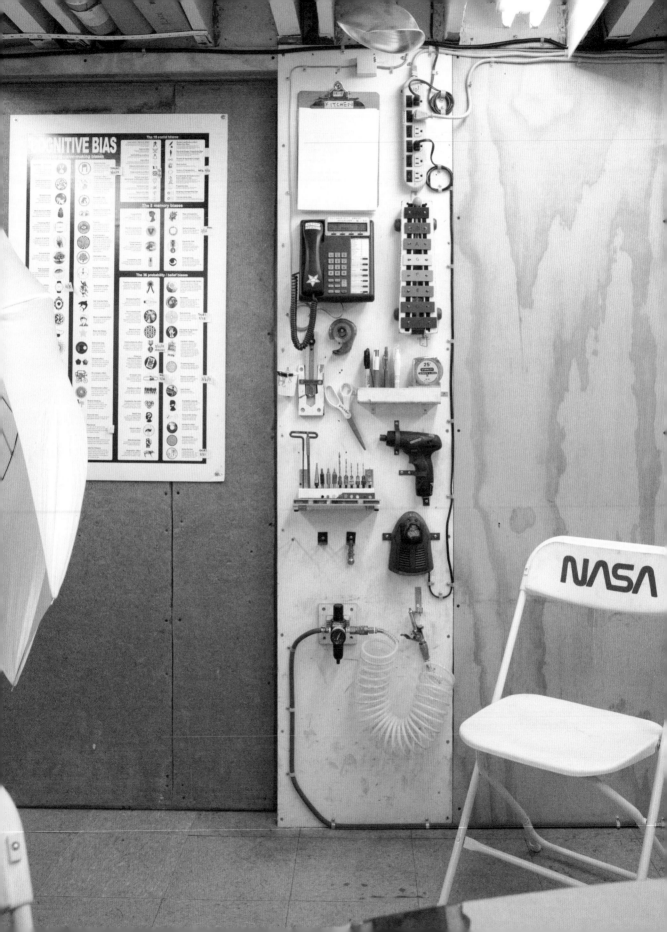

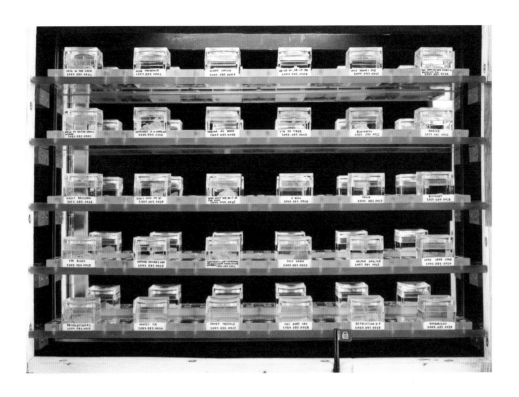

TOM SACHS

Knollmaster General Tom Sachs is an art-world giant. His studio practice is encapsulated in the film *10 Bullets*, which highlights the mantra, "Always be Knolling." Sachs was an early inspiration, his books constant companions. My online contact with his studio led to an internship with his exhibition *Space Program 2.0: Mars* at the Park Avenue Armory. Just as NASA's early excursions captured the collective imagination in the 1960s, my connection to Tom makes anything seem possible.

Sachs's artistic practice is all about hard work, discipline, craftsmanship, and authenticity. His tool cabinets and "scars of labor" celebrate the equipment, time, and dedication involved in creating his sculptures.

Tom Sachs has exhibited in galleries and museums worldwide, including the Deutsche Guggenheim, Berlin, and in New York at Gagosian Gallery, Lever House, the Museum of Modern Art, Park Avenue Armory, and Sperone Westwater.

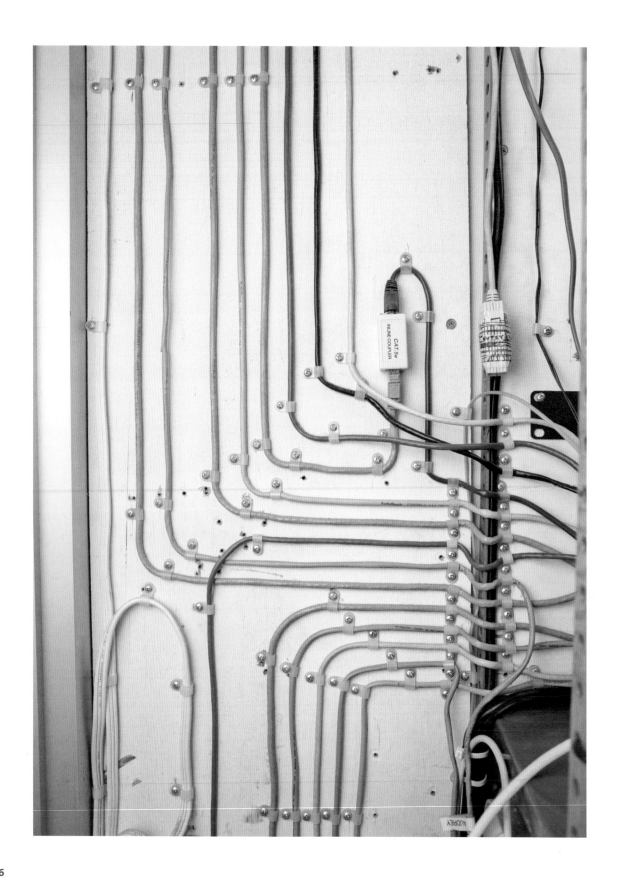

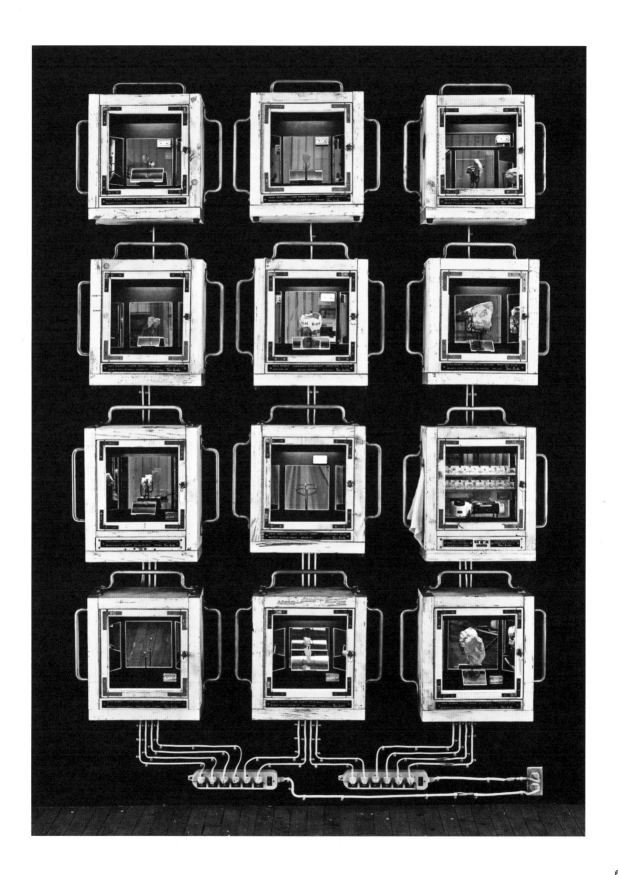

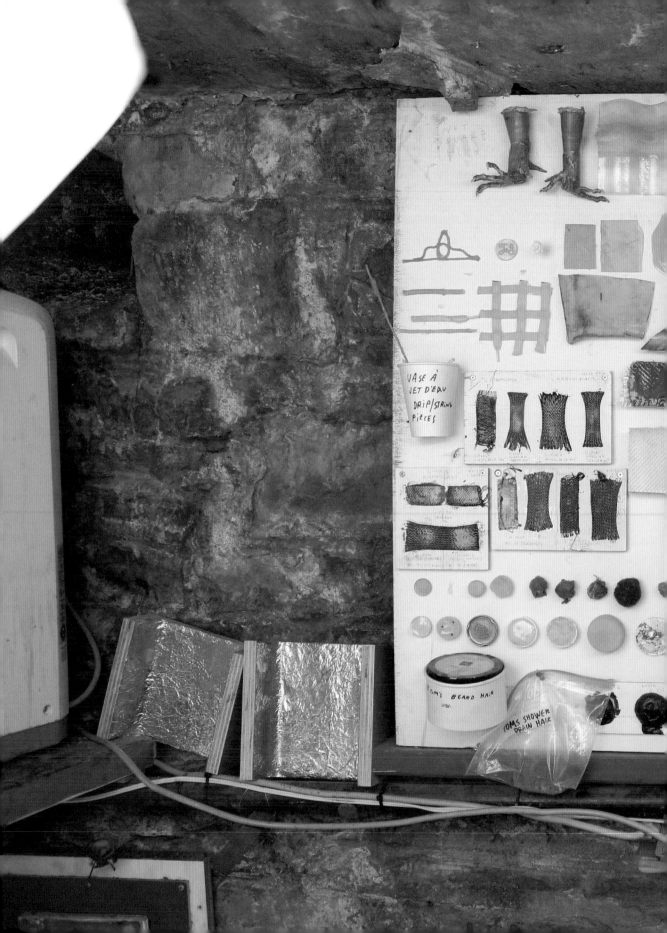

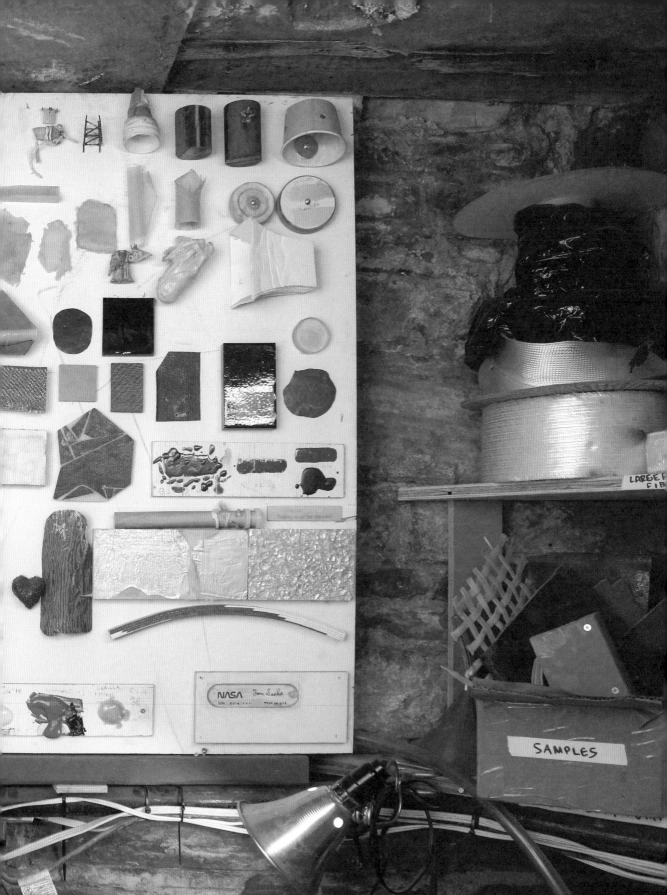

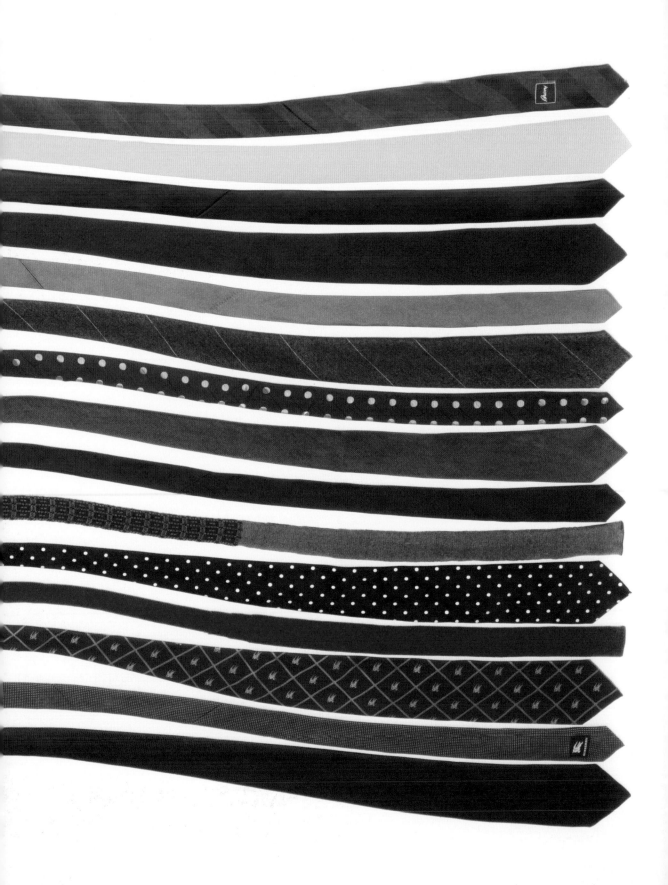

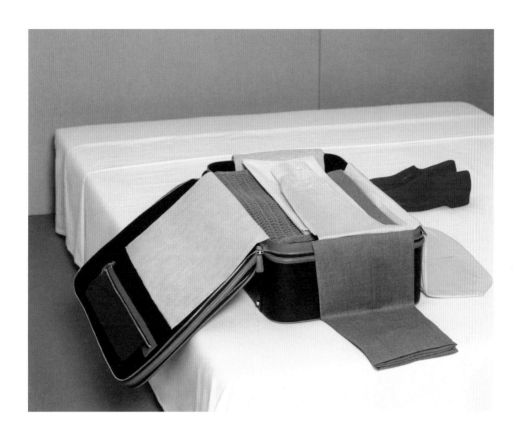

SCHELTENS & ABBENES

I first made contact with Scheltens & Abbenes about a year into the *Things Organized Neatly* project when they submitted their photographs for the blog. I was already a great admirer of their meticulous and exacting work, and was thrilled to hear from them. It was an important moment for the blog as an early example of artists submitting their work to me directly. We've been in steady contact ever since, and I am pleased to be able to showcase some of their work in this format. Their clients include some of my favorite fashion houses and magazines COS, *The Gentlewoman*, Kenzo, and *Wallpaper**, as well as museums and galleries around the world.

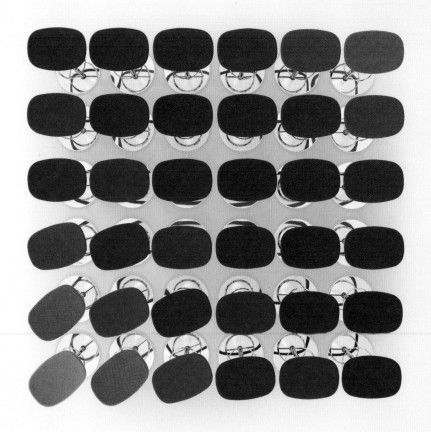

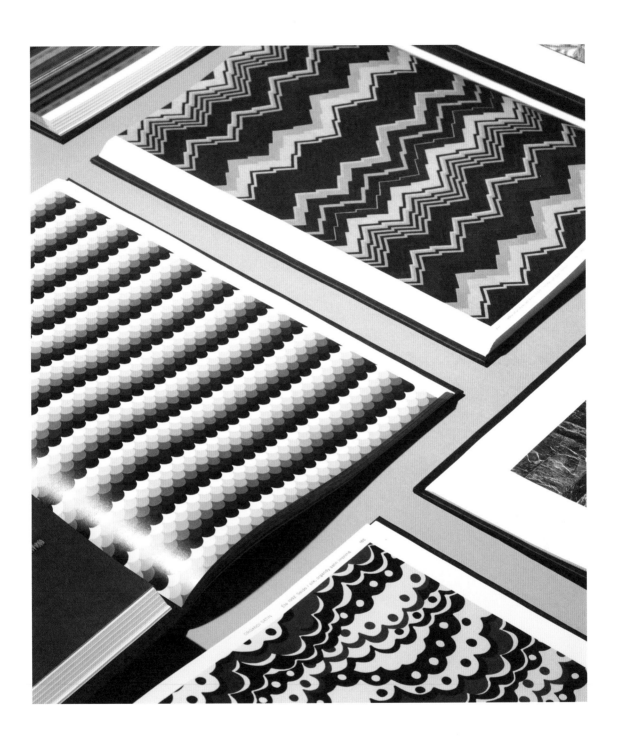

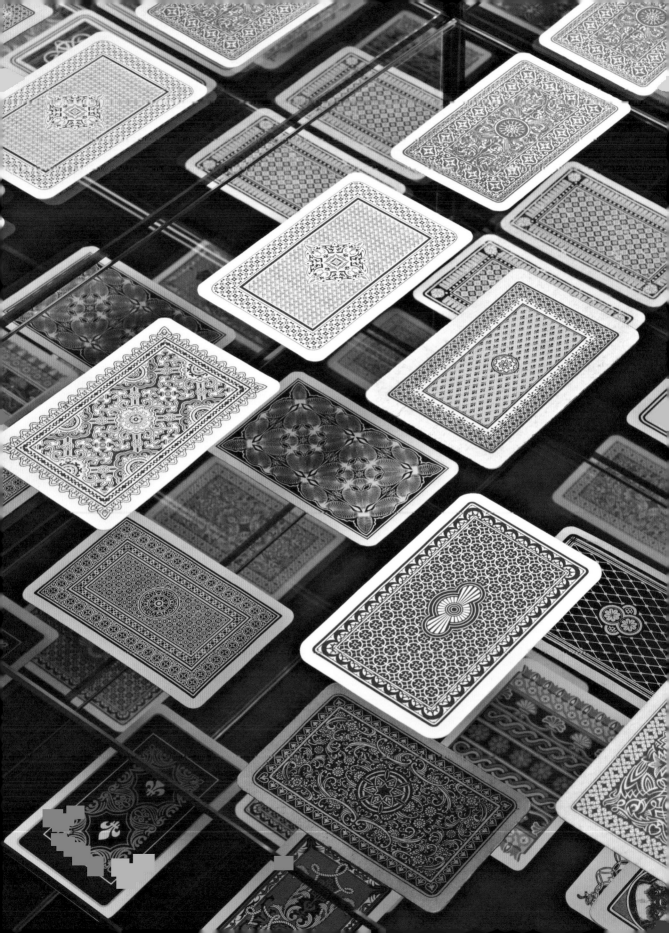

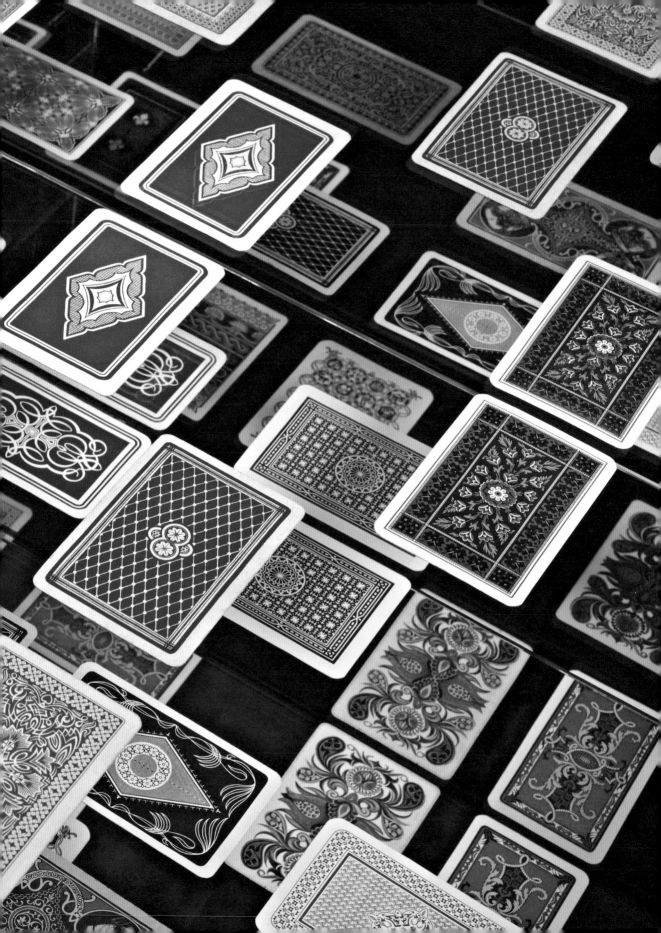

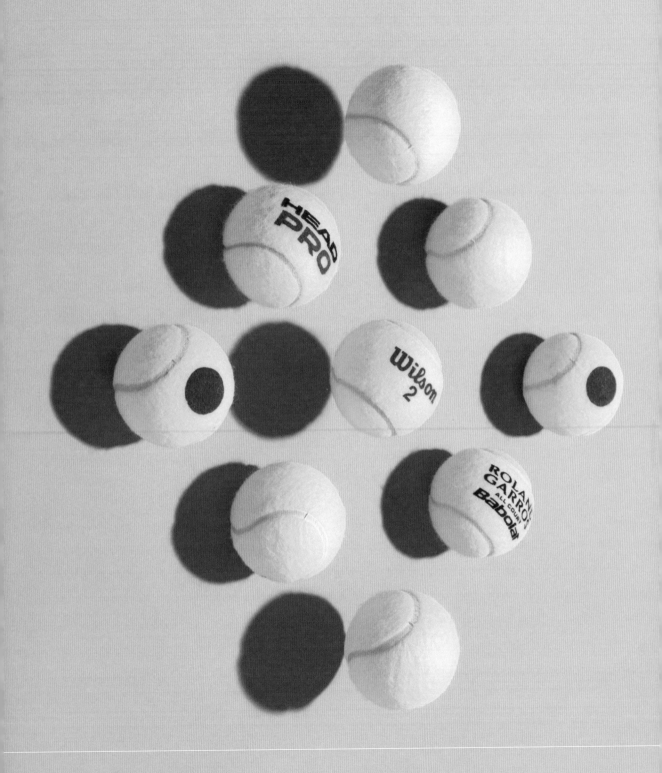

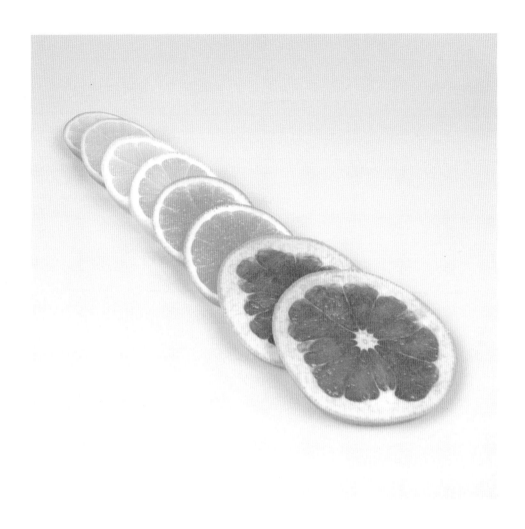

FLORENT TANET

Florent Tanet is a French photographer and art director. His *Colorful Winter* series captured the Internet's attention for its understated color palettes and sharp, orderly lines. The project caught my eye for its inventive ways of altering and splicing together fruits and vegetables. Tanet's photography has been commissioned and featured by the likes of Chanel, *Citizen K*, *Fast Company*, *L'Officiel*, *M le Magazine du Monde*, and *The New Yorker*.

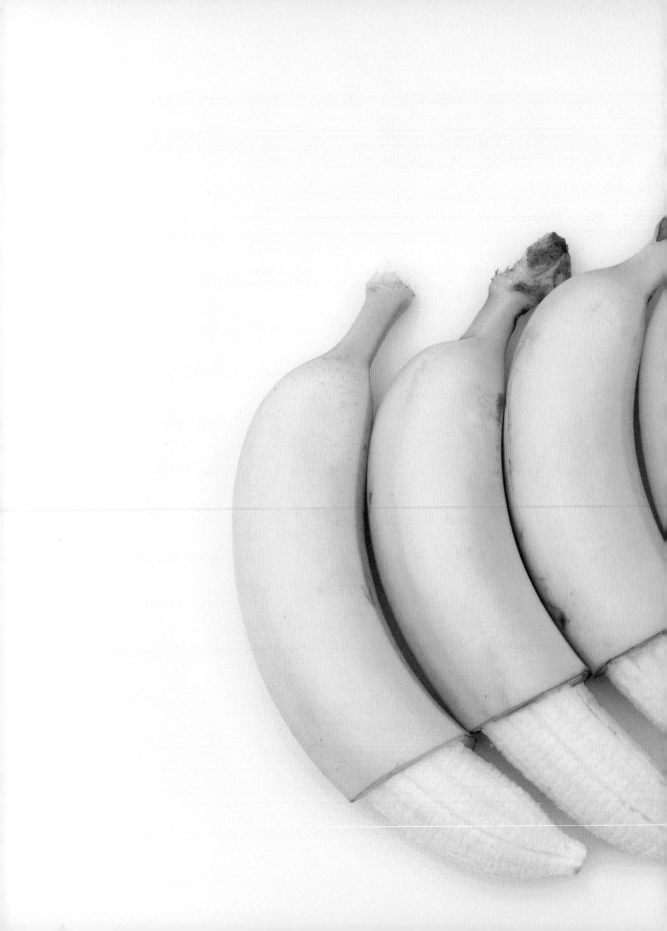

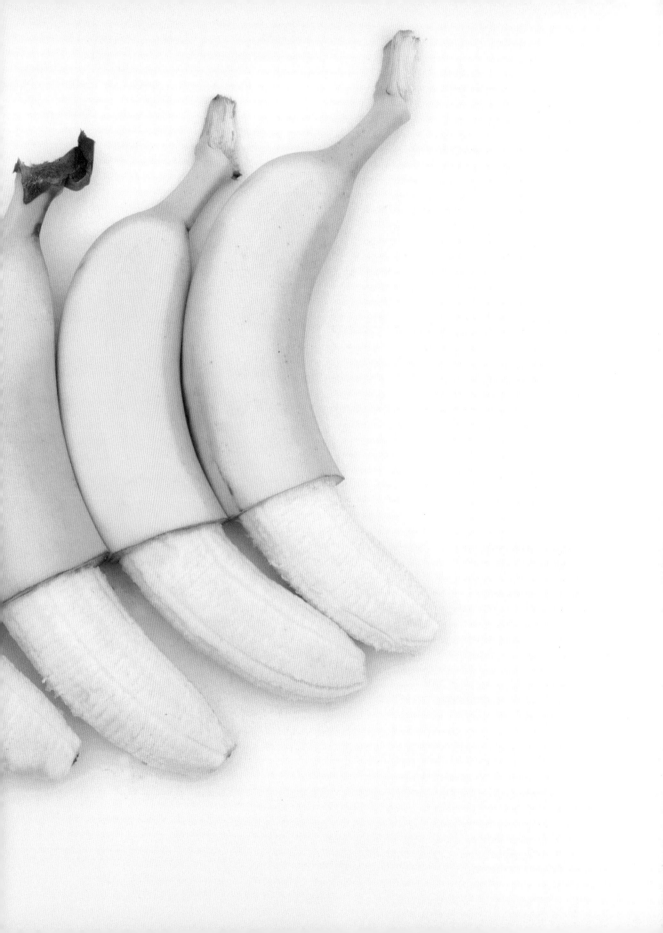

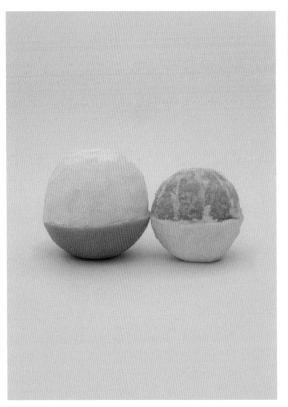

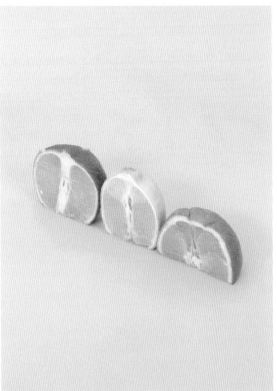

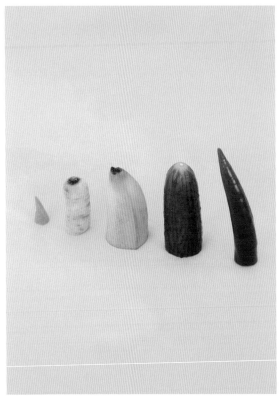

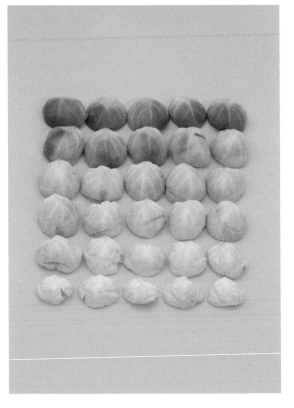

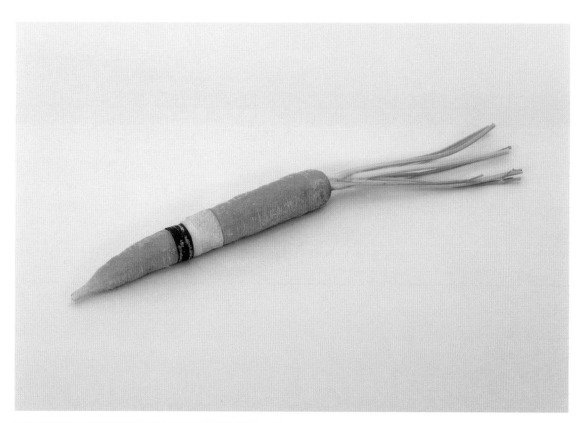

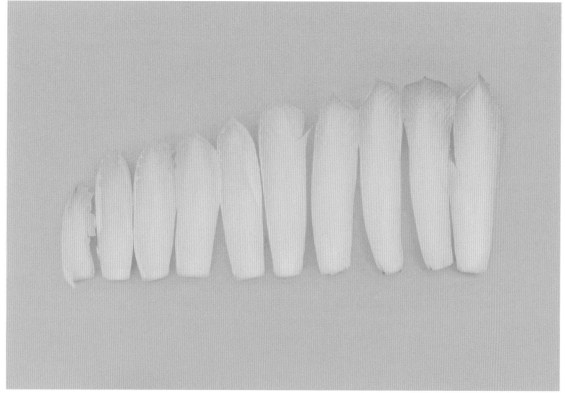

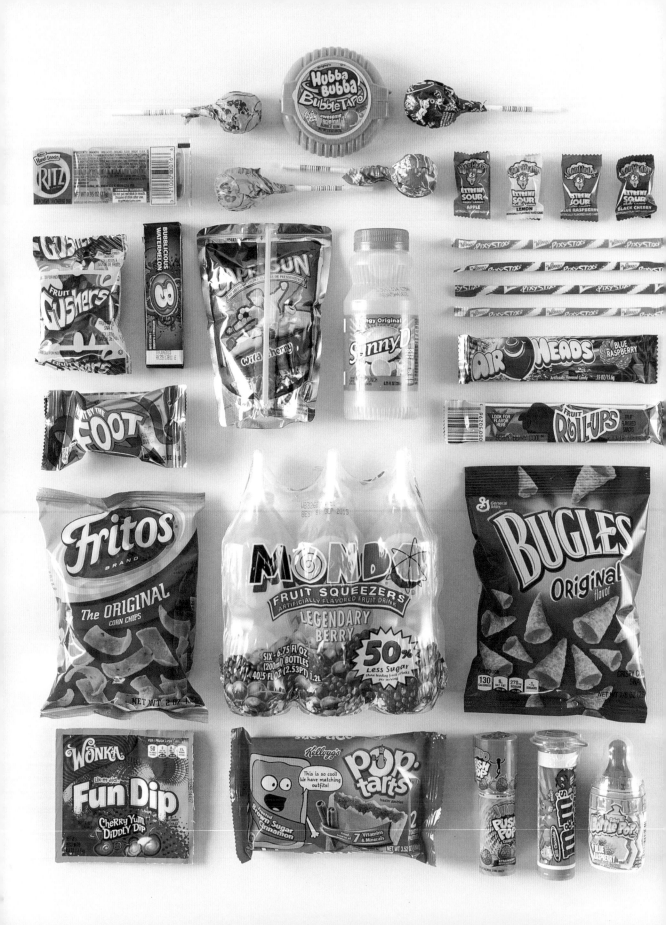

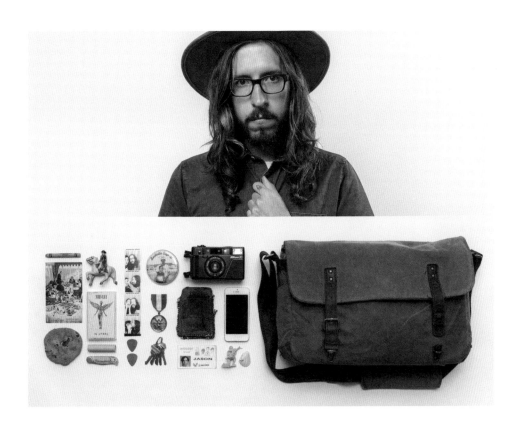

JASON TRAVIS

The *Persona* series by Jason Travis is an Internet favorite and a vehicle for storytelling. The concept is simple: pair a photo of a person with a photo of his or her essential belongings. The result is a unique, two-sided portrait of a person. Travis's work is always a fan favorite on *Things Organized Neatly*. Based in Atlanta, he shoots still lifes, portraits, and other projects for clients such as Adult Swim, MailChimp, and Refinery 29.

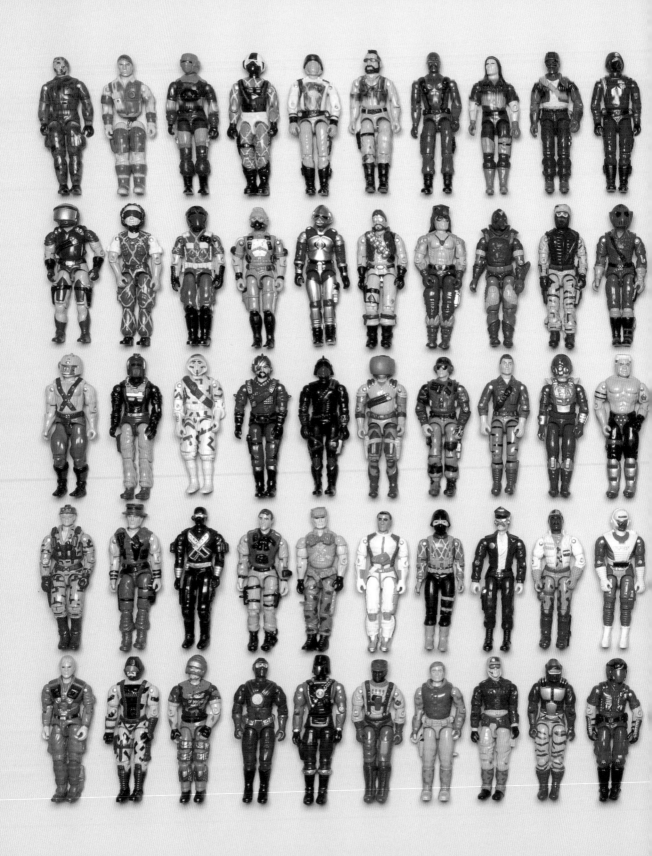

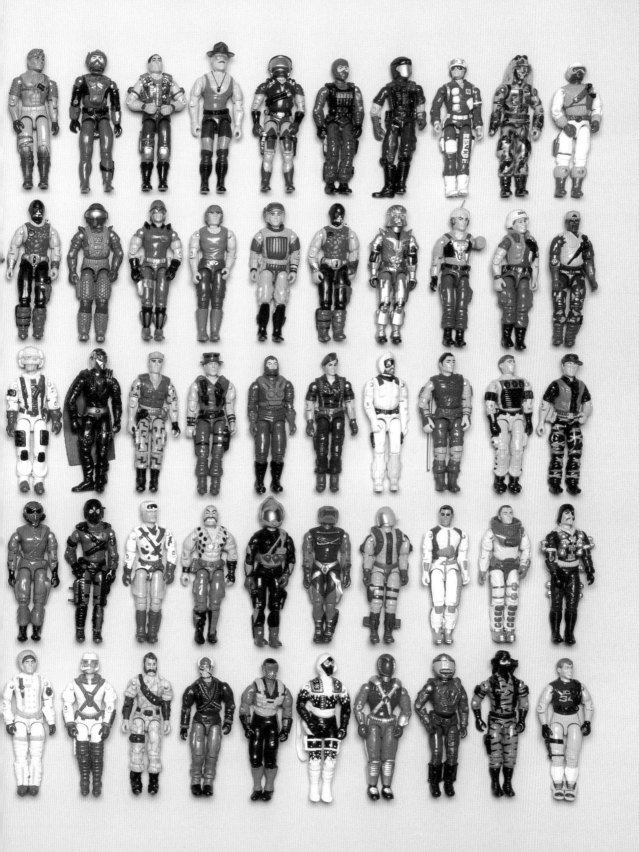

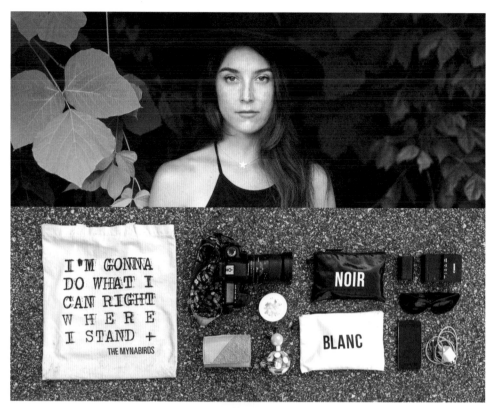

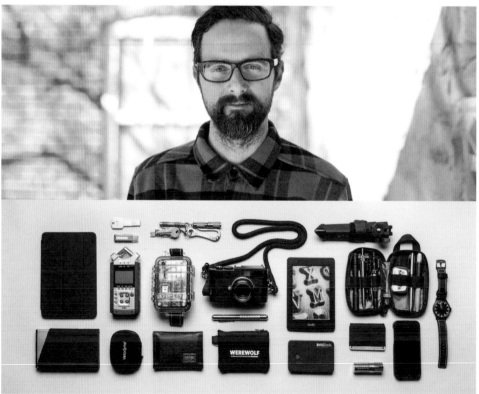

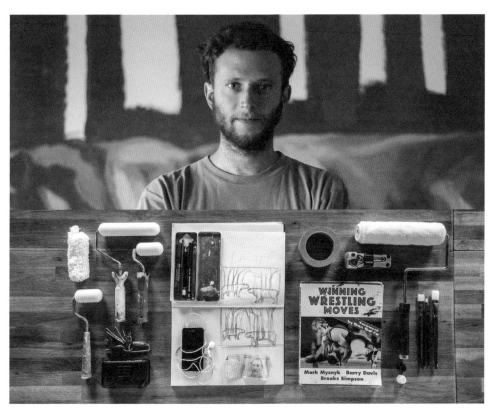

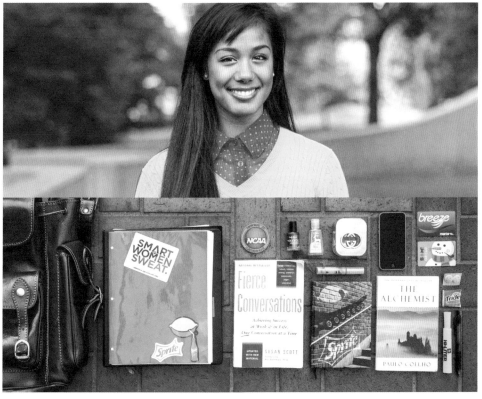

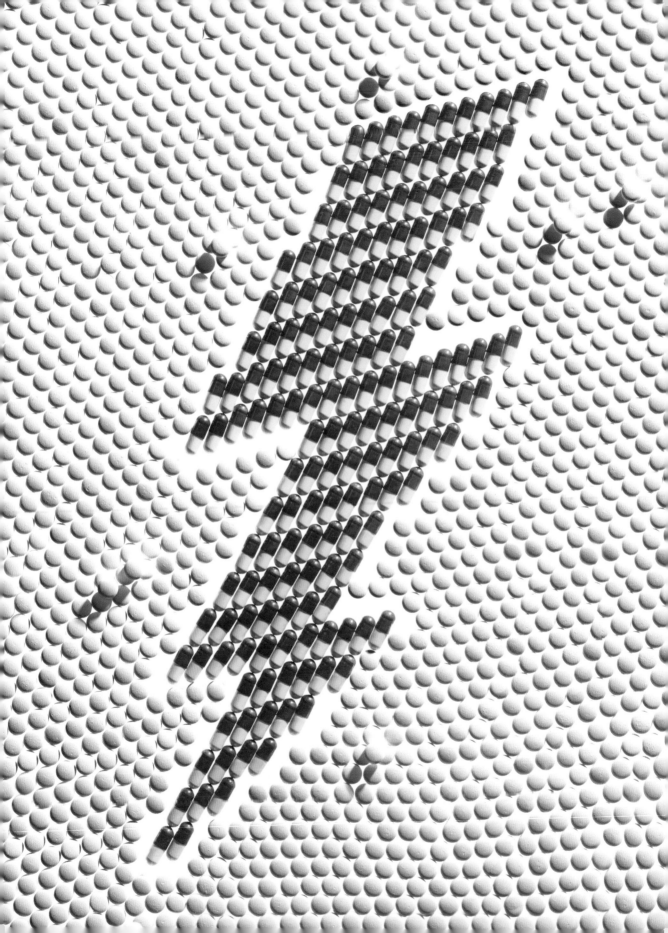

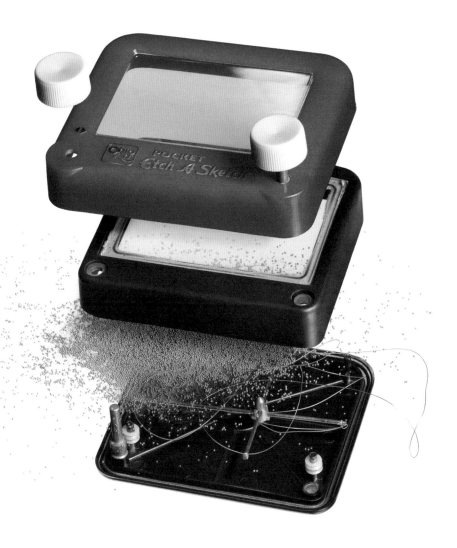

THE VOORHES

The Voorhes' *Exploded* series first caught my attention with their masterful use of photography to create visual diagrams that would normally be accomplished by illustration. The collaborative duo of Adam Voorhes and Robin Finlay continues to design and execute clean, impactful still-life photography for clients such as *Bloomberg Businessweek*, BMW, *GQ*, *ESPN The Magazine*, and *Wired*. Together the Voorhes complement each other's artistic strengths, while experimenting and elevating their work to new heights.

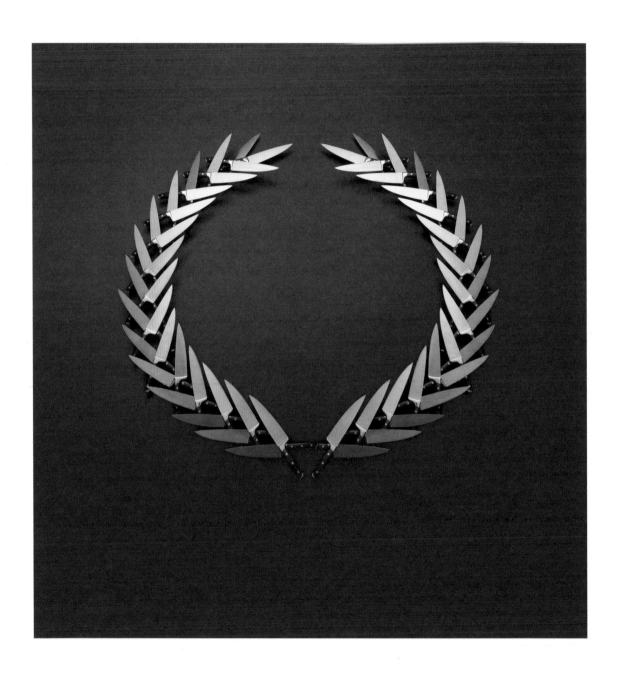

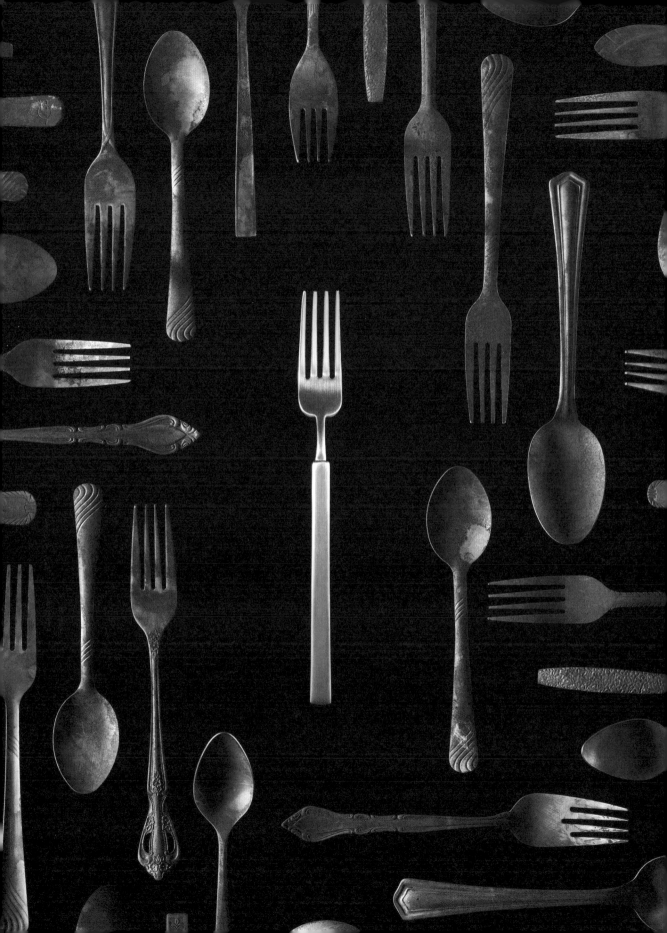

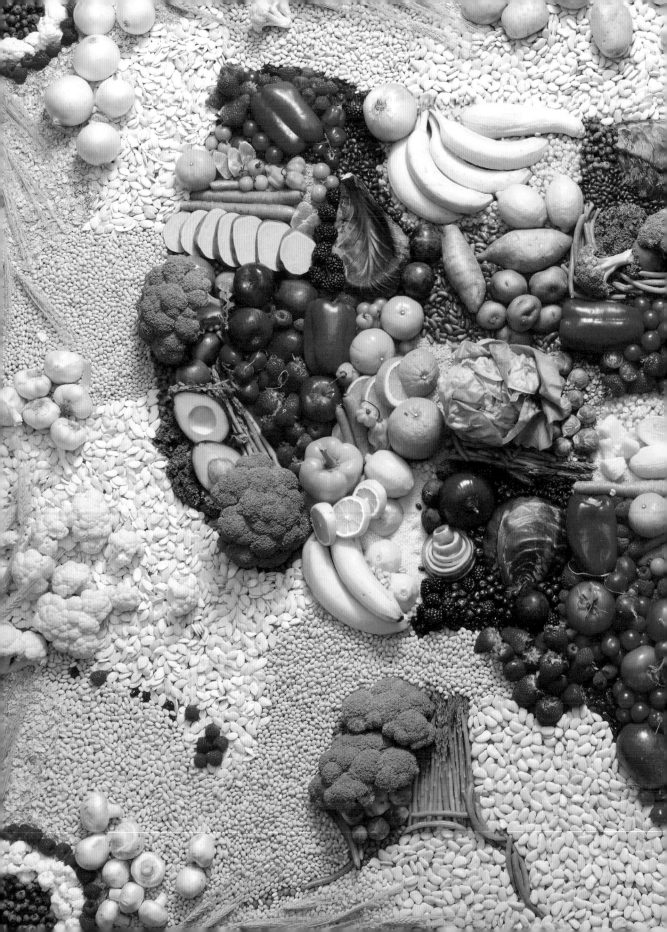

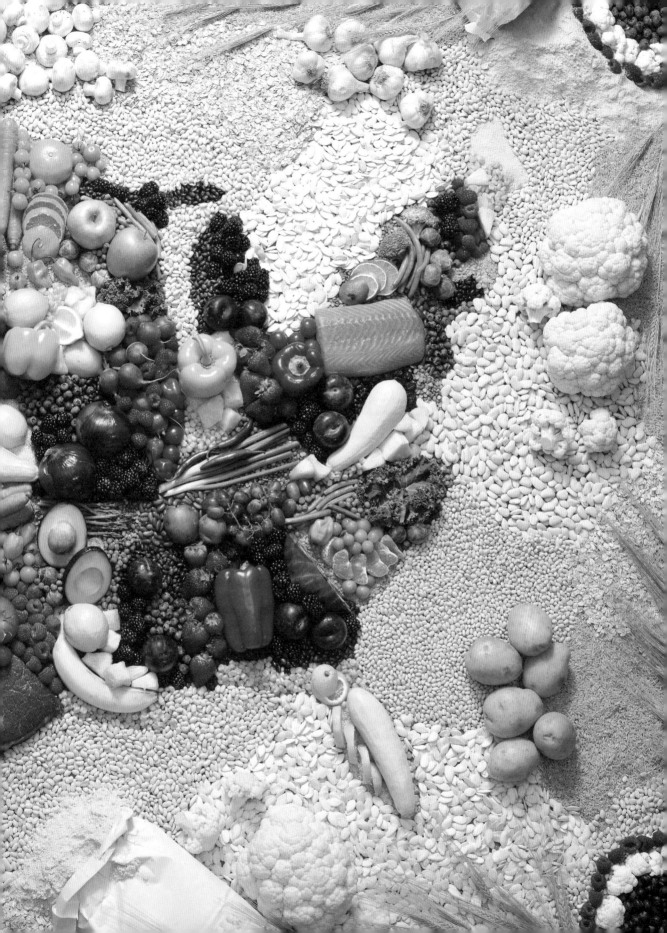

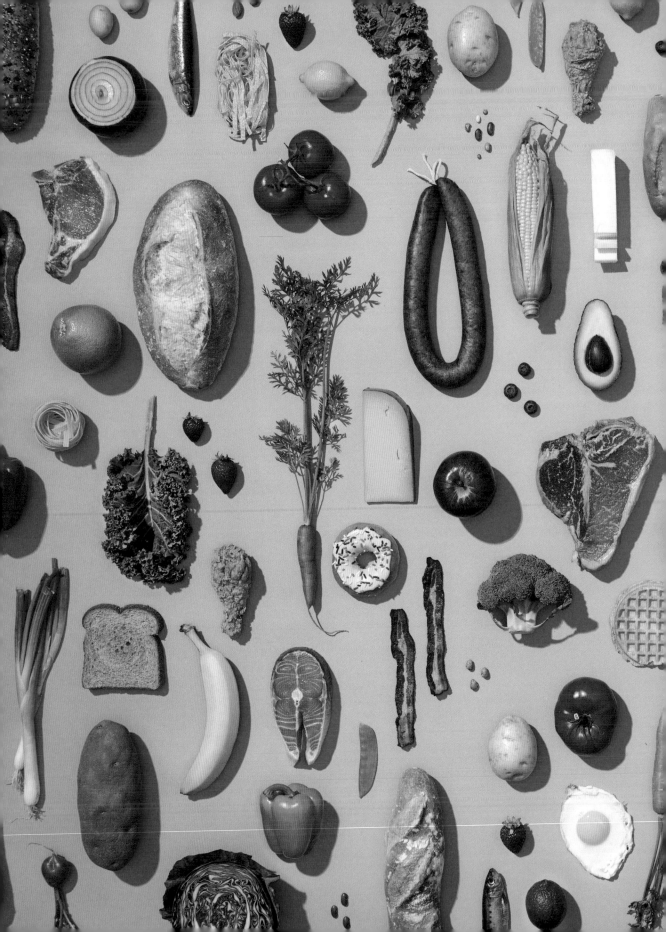

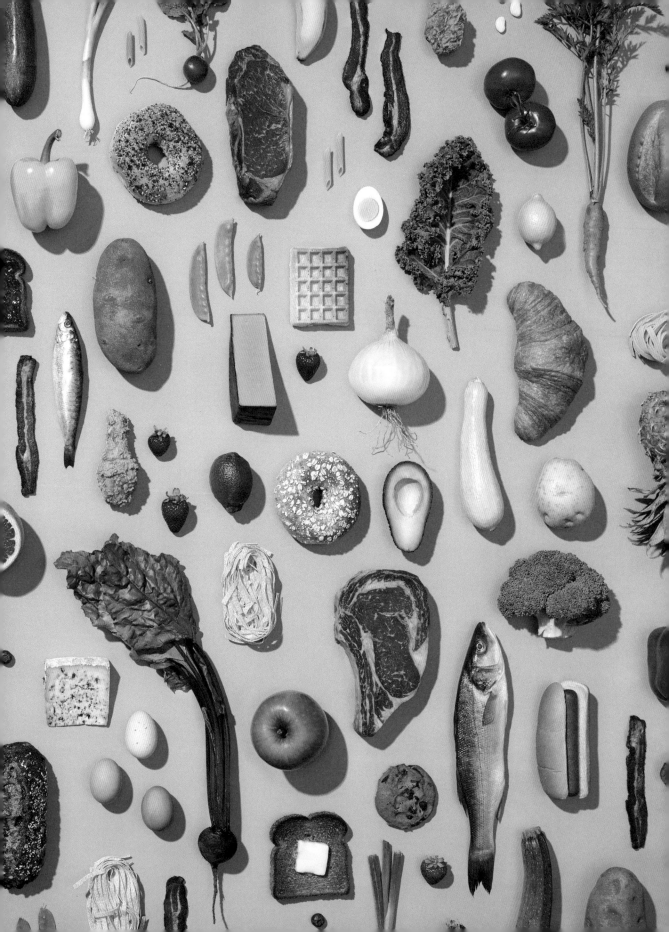

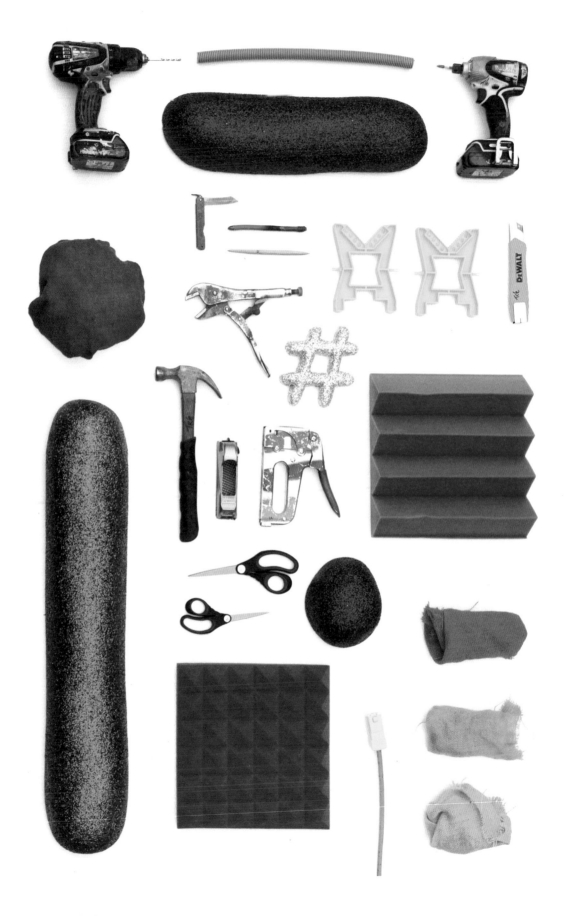

ACKNOWLEDGMENTS

This book is the culmination of a five-plus-year online project. My goal was never to make money, but to make a mark. To make an impact in the vast cultural abyss of the Internet. I think it worked.

I owe special gratitude to Joe Davidson and everyone at Rizzoli, to Tom Sachs for his magnanimity, to Aaron Finley for his invaluable assistance in writing the introduction, to all of the contributing artists, and to my parents for teaching me how to talk to strangers.

Below is an alphabetical, incomplete list of people who made large and small contributions to *Things Organized Neatly*, helped with photo shoots, or otherwise supported my endeavors:

Taryn Cassella, Confetti System, Jessie Cundiff, Nick Gamso, Jared Geller, Samantha Haas, Jake Harris, Amanda Jasnowski, Adam JK, Polina Joffe, Katie Keller, Lauren Kester, Sascha Liff, Jill Marie Mason, Alex Mikos, Casey Neistat, Tré Reising, Tom Sachs Studio, Brooke Shanesy, Dana Sherwood, Leyla Tahir and everyone at the Tate galleries, Joe Vandehatert, Peter Van Hyning, Melanie Warner, Cori Wolff, B. Wurtz, and the 2005 Yankee Racers.

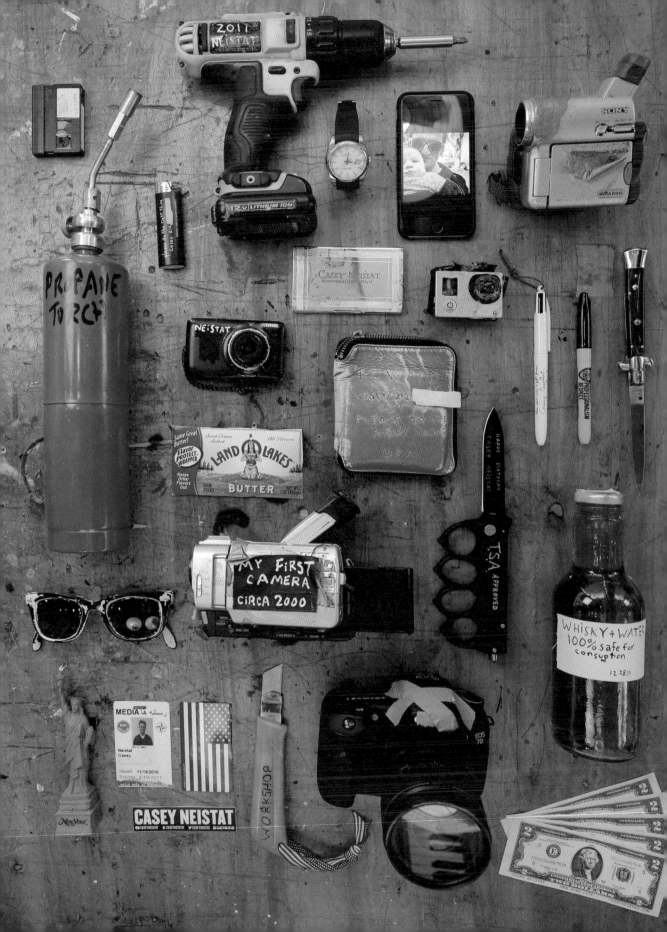

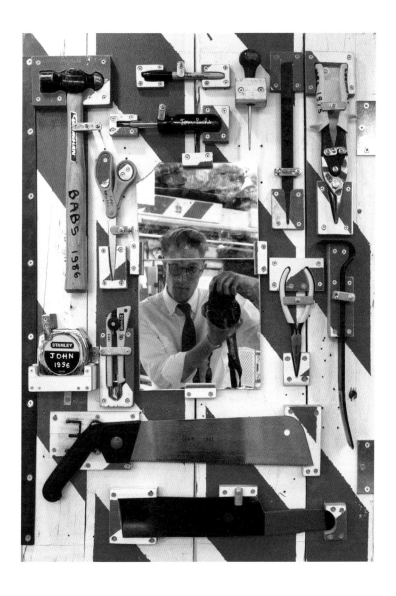

ABOUT THE AUTHOR

Austin Radcliffe is an American curator, blogger, photographer, and *cyberflâneur* who currently splits his time between the Midwest and New York City. *Things Organized Neatly* was created in 2010, while Radcliffe was studying at Herron School of Art and Design in Indianapolis. *Things Organized Neatly* has garnered invitations from Tate Collectives in London, The Webby Awards, and the Internet at large.

CREDITS

All work appears courtesy of the artist, unless otherwise noted.

Page 1
Sarah Illenberger, *Tutti Frutti*

Pages 2–3
Brooke Shanesy for Brush Factory

Page 4
Jim Golden, *Instrument Collection*

Page 6
Sam Kaplan, *Still Life, Gum Flossers*

Pages 8–9
Jim Golden, *Typewriter Collection*

Page 10
Austin Radcliffe & Brooke Shanesy, *Springs Organized Neatly*

Page 12
Henry Hobson for the Academy Awards
Grand Budapest Hotel
Directed by Wes Anderson

Page 13
Things Organized Neatly
for Tate Collectives
Styling by Austin Radcliffe & Jessie Cundiff
Photograph by Studio V Cincinnati

Page 14
Tom Sachs Studio, *Armory For the War on Plywood (AFWOP)* (detail), 2012
Mixed media
99 x 130 x 130 inches
Photo credit: Genevieve Hanson

Page 16
*Mark Dion, *The Aerial Realm*
India ink on paper

Page 17
*Mark Dion, *The Unruly Collection*
Wooden cabinet, luminescent paint, and forty-three papier-mâché sculptures

Page 18
Top
*Mark Dion, *Humboldt Cabinet*
Wooden cabinet, brass hinges, glass, pencil, and watercolor on paper, stamp
Bottom
*Mark Dion, *Phantoms of the Clark Expedition (Equipment)*
Colored pencil on paper

Page 19
*Mark Dion, *Palaearctic*
India ink on paper

Page 20
Jim Golden, *Cannondale Track Collection*

Page 21
Jim Golden, *Lock Collection*

Pages 22–23
Jim Golden, *Barrette Collection*
Styling: Beverly James Neel

Page 24
Jim Golden, *Relics of Technology: 3-inch Floppy*

Page 25
Jim Golden, *Relics of Technology: Microcassette*

Pages 26–27
Jim Golden, *Sewing Machine*
Styling: Beverly James Neel

Page 28
Sarah Illenberger, *Untitled*

Page 29
Sarah Illenberger, *Chewing Gum*
From the *Odds & Ends* series

Page 30
Sarah Illenberger, *Mini Meloncholy*
From the *Tutti Frutti* series

Page 31
Sarah Illenberger, *Calorie Counting*
For *The New York Times Magazine*

Page 32
Top & Bottom
Sarah Illenberger, *Evolution*
With FSB/Realgestalt
Photograph: Attila Hartwig

Page 33
Sarah Illenberger, *Chilli con Carne*
For *enRoute*

Page 34
Michael Johansson, *Ghost V*
Exhibition at The Flat – Massimo Carasi, Milan, Italy

Page 35
Michael Johansson, *Box Office*
Installation at Rådhusgalleriet, Oslo City Hall, Oslo, Norway

Pages 36–37
Michael Johansson, *Last Summer,* 2014
Coolers and CoolPaks
Installation at Malmöfestivalen, Malmö, Sweden

Page 38
Michael Johansson, *Self-Contained,* 2010
Installation at Umedalen Skulpturpark, via Galleri Andersson/Sandström, Umeå, Sweden

Page 39
Top left
Michael Johansson, *Domestic Kitchen Planning*
Kitchen stool and kitchen equipment
Top right
Michael Johansson, *Frozen Belongings*
Bottom left
Michael Johansson, *Faded Memories*
Armchair, books, boxes, cameras, radio, etc.
Exhibition at Galleri Arnstedt, Östra Karup, Sweden
Bottom right
Michael Johansson, *Tipi - Konsthallen Trollhättan*
Objects from the storage room at Konsthallen Trollhättan

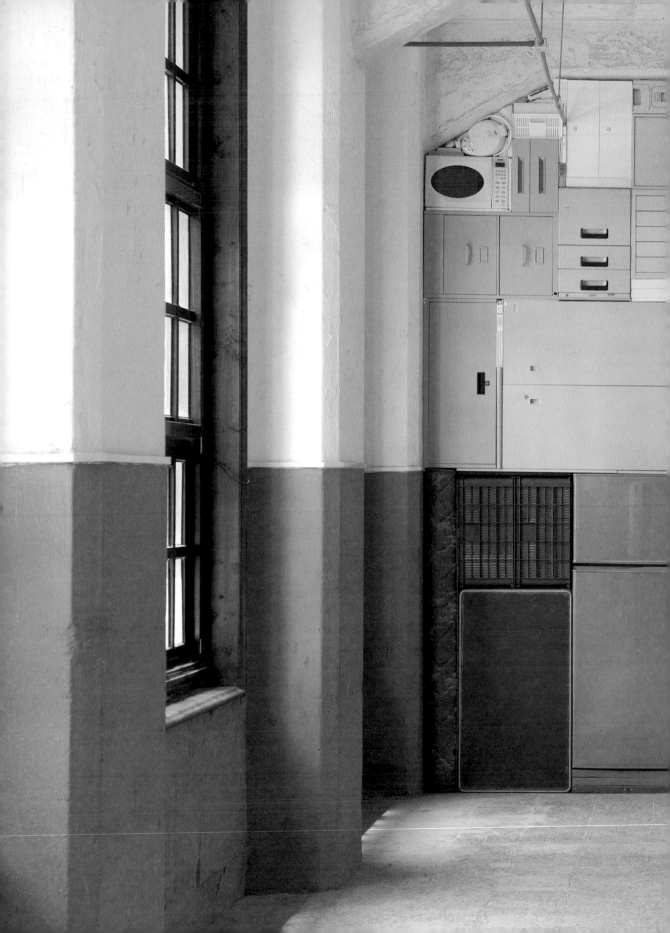

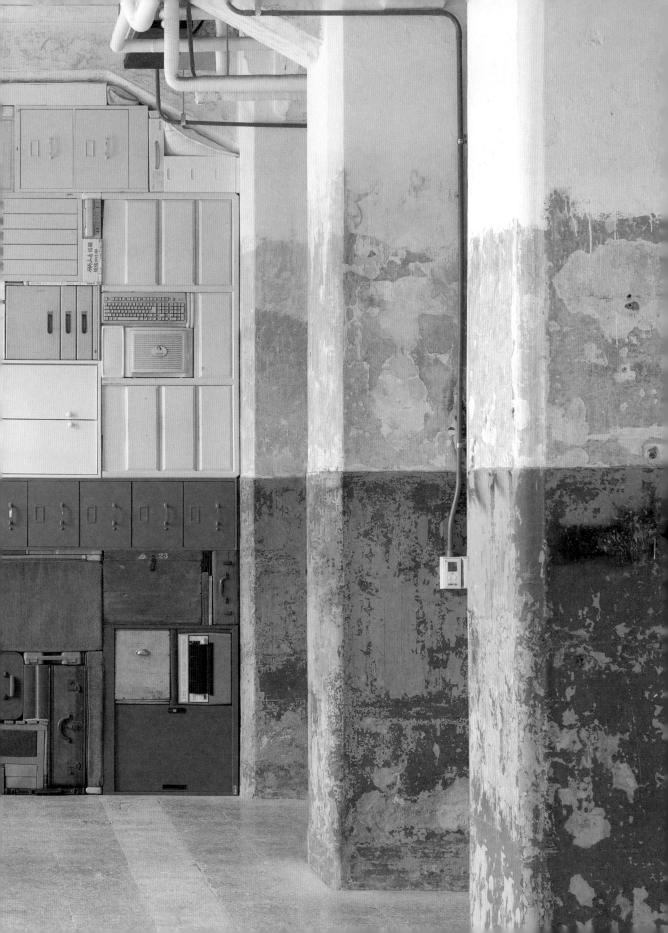

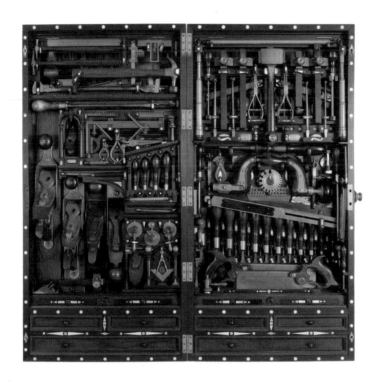

First published in the United States of America in 2016 by
UNIVERSE PUBLISHING
A Division of Rizzoli International Pulications, Inc.
300 Park Avenue South
New York, NY 10010
www.rizzoliusa.com

ISBN-13: 978-0-7893-3113-7
Library of Congress Control Number: 2015951787
© Austin Radcliffe

Design by Kayleigh Jankowski
Universe Editor: Joe Davidson
Production Manager: Kaija Markoe

All rights reserved. No part of this publication may be reproduced, stored in a
retrieval system, or transmitted in any form or by any means, electronic, mechanical,
photocopying, recording or otherwise, without prior consent of the publisher.

Distributed to the U.S. Trade by Random House, New York
Printed in China
2016 2017 2018 2019 / 10 9 8 7 6 5 4 3 2

Front cover: Jim Golden, *Barrette Collection* (styling by Beverly James Neel)
Back cover: Michael Johansson, *Ghost V*